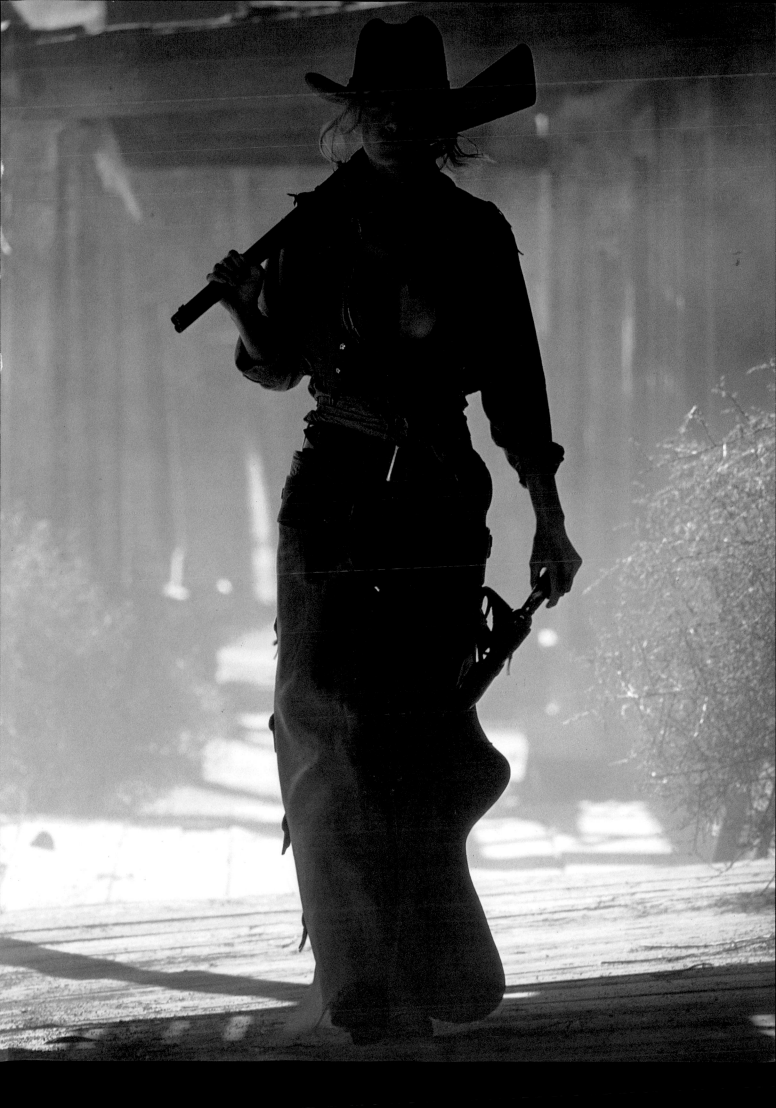

THE VERSATILE

PHOTOGRAPHER

LARRY DALE GORDON

AMPHOTO, an imprint of Watson-Guptill Publications/New York

Larry Dale Gordon grew up and was educated in southern California, but an addiction to travel manifested itself early in his life. Motivated by the freedom of travel and ability to work as an independent artist, Gordon changed career direction from architecture to photography. Since the age of eighteen, he has traveled and worked in more than sixty countries around the world and has lived in London, Rome, and other European capitals.

For more than twenty-five years, he has worked for international clients, doing advertising and editorial photography, with travel and location work being predominant. His photographs have been published throughout the world in major magazines and through major advertising agencies.

Gene Butera, art director of Detroit's Campbell Ewald agency, has said of him: "Larry Dale Gordon discovered long ago that he has two consuming interests: travel and photography. He also realized that by combining the two, he could create an ideal career. Some twenty years and sixty countries later, Larry shoots exotic locations, people, beauty, fashion, cars, and a host of other subjects with equal enthusiasm. His photographs...are ample testimony to the fact that both his wanderlust and his reputation as an artist are secure."

Copyright © 1987 by Larry Dale Gordon.

First published 1987 in New York by AMPHOTO,
an imprint of Watson-Guptill Publications,
a division of Billboard Publications, Inc.,
1515 Broadway, New York, NY 10036

Library of Congress Cataloging in Publication Data

Gordon, Larry Dale.
 The versatile photographer.
 Includes index.
 1. Photography. I. Title.
TR145.G628 1987 770 87-19315
ISBN 0-8174-6359-3
ISBN 0-8174-6360-7 (pbk.)

Manufactured in Japan

1 2 3 4 5 6 7 8 9 / 95 94 93 92 91 90 89 88 87

*For my lovely mother who told me
the last half was the best half...*

CONTENTS

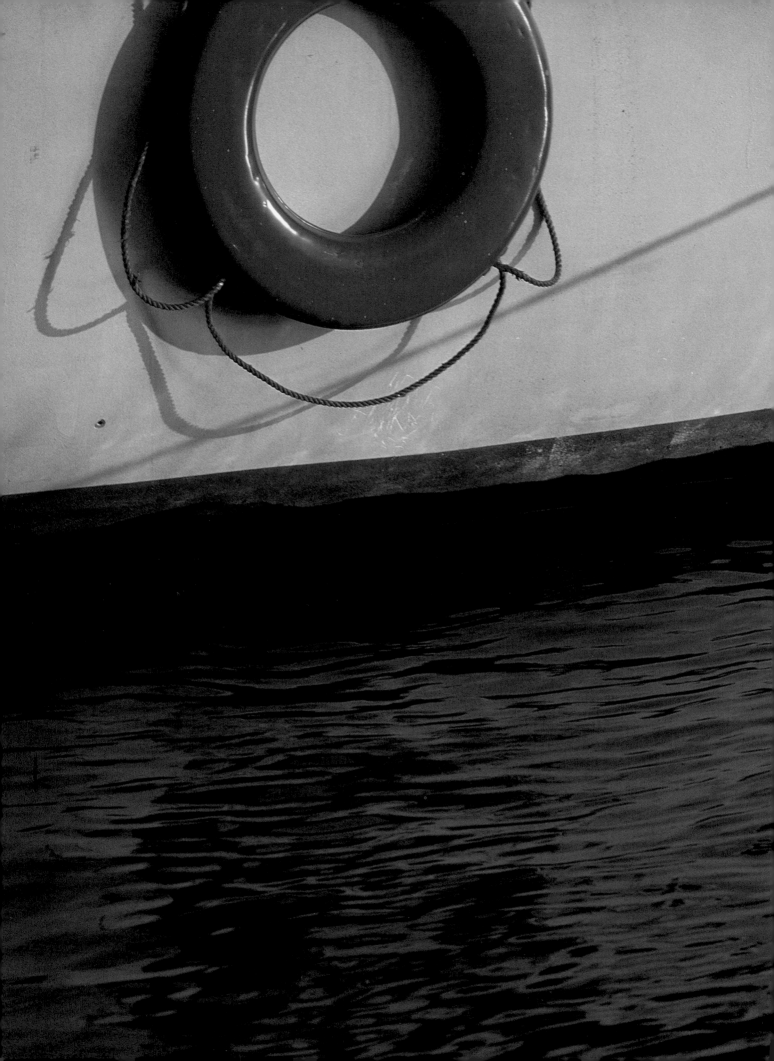

INTRODUCTION

As the idea for this book began to emerge, a sobering realization came along with it. How would I make a "How to" book on a subject as intangible as versatility? It's like trying to describe an emotion by way of a diagram. If photography is an art form, as many of us claim, how could I attempt to explain such ethereal subject matter with diagrams? Therefore, I have decided to take an entirely different approach.

There will be no diagrams in this book, other than those created out of words and ideas illustrated by photographs. My purpose is to bring about a better understanding of how and why myself and other creative people bring home "the goods," or make it to the "top," wherever that might be.

To me, versatility applies to more than just the taking or making or photographs; it also means looking at life from more than one approach, with more than one attitude. You photograph something from more than one direction, why not look at life in the same way? Why not also understand and be involved in other arts, in food and wine, music and fashion? Photographers, as purveyors of art, need not look like aliens from another planet. You may now be saying: "Creativity is the thing; nothing else matters." I feel differently. Not only *can* you develop a style of sorts, it is imperative that you do so. Picasso had great style; so did Man Ray; so does David Hockney. Great artists are involved in more than their specialty, more than is called for. It is all part of the creative process, of being innovative, of being versatile.

Style, as a photographer and in your photography, is important. But to be versatile is also to be adaptable, to be innovative, and, again, to be creative. It is a most rewarding experience to know that you can be dropped into almost any situation and adapt; to be able to create a photograph out of nothing, in the middle of nowhere. You must be innovative in all aspects of your art: your approach; your application of technique; light; your use of equipment, models, products; and your relationships with art directors or editors.

Above and beyond this, you must learn to *see* and you must learn the basic element of this art, of this profession: light. It has always been remarkable to me how little most people see as they move through life. Photography has taught me how to see and hopefully record a small percentage of those images. For that, I am forever grateful. There are pictures everywhere; design and graphics, color and shadow, starkness and mood are present in all things.

Hockney has said, "The trouble with photography is that everything is seen through a small round hole." I plead guilty; I tend to see life and all things through a 35mm hole and it's limiting. I'm continually trying to break the habit, but almost thirty years of seeing that way makes it difficult to change. I want to photograph everything. Sometimes I wish I had a shutter integrated into my head, so

that I could click with the blink of an eye and record all those images I see with each passing day. The challenge is, of course, putting the machinery in between at the right moment—the decisive moment. It's learning to put all the elements together at a given time, to be innovative enough to capture them with your own style and personal touch.

The so-called secret of our profession (all professions have at least one) is light. It is not just the secret of photography, it *is* photography. As Charly Potts always said, "Learn the law of light." One could get into philosophical discussion here, pondering whether an object is really there unless light reflects from it and registers as an image in your mind's eye. Deep thoughts, but in reality it is the light that makes the object visible and, more important to the photographer, photographable. Think about this: light does not come in a pre-wrapped package, all ready for use; it comes in an infinite variety of quality and color, both natural and artificial. If you learn how to recognize it, use it, and make it work for you, you will be way ahead of the game. Light can sometimes puzzle you, frustrate you, even enrage you, but for the most part, it will amaze and enlighten you, leaving you humble in its simple, but awesome glory. I sound a bit dramatic, but I am an incurable romantic and an emotional character when it comes to light and most other natural elements given us by Mother Nature or some other prime mover. I also cry at movies.

As we move through the book, I'll try and point out my use and the different applications of light, both natural and artificial. Although I am an advocate of natural light and believe you can do almost everything with it, strobe is an art form as well. If you learn how to work well with strobe, it can be a beautiful source. It also allows those studio guys to work late after the sun goes down and make all that money.

I arrived at this point in my professional and personal life like any other overnight success, of course. Aside from the fifteen or twenty years of hard work I've put in, tenacity I've had, and luck that's come my way, I believe I was born with a good eye. As always, there were other mitigating circumstances, all of which have added to the style and look of my pictures.

I've always felt I marched to a different drummer and he was always playing a theme of travel. The variation on the theme was restlessness; I was an impatient youth. As a young lad, I read more maps than books and longed to go to all the romantic places in the world; places with names like Valparaiso, Shanghai, Denpasar, Nairobi, The Maldives, Patagonia, Hong Kong, and Papeete. Needless to say, when I got there some were more romantic than others. But the wonderful thing was to make that discovery on my own and I've never been to a place I didn't like or appreciate in some way. Everyone has their indulgences, I'm a travel addict, as you will see.

The U.S. Army really got me in gear. They sent me to Germany as a young (very young) boy of 18 and the addiction was planted. Imagine a naive kid, just out of high school, being dropped into an endless parade of voluptuous blond women (all older at 20!), great beer, schnapps, and cities and castles older than America. It was incredible. Some men (boys?) were homesick. I couldn't understand it. Were they crazy? My mom was wonderful, but home was never like this!

I began to see; to see so many different things. Not only the countryside, but a different way of life; different attitudes, styles, food, and humor. I knew then how diversified the world really is outside the United States. We American are a naive lot, but that's a different story altogether.

The stay in Germany and Europe and the photographs I did there started me thinking. I knew there was something in travel for me, but I still wasn't on a permanent photographic track. Although tearful at leaving Europe, I did come back to the States, realizing I definitely needed more classroom education. I began studying architecture, which I felt to be the most creative and monumental of the arts, but (and it was a big "but" then) it meant staying in one place for years. Plus the math was murdering my grades. (Or to be more honest, I was murdering the math *and* my grades.) I kept thinking of one school, one desk, one office, one city, one country—it wouldn't compute. I also kept thinking of those lazy, crazy days in Copenhagen, Munich, Paris, the bull runs at Pamplona, and the beaches at St. Tropez. "On The Road Again" had to be my song; there was just too much out there, too much to see and do, even considering the great payoff architecture must give to its artists.

As you may have surmised by this time, no great philosophical reasoning drove me to photography, no burning desire to record history, or a war, or hang in the world's museums. Photography was seen as a vehicle for the kind of life I wanted to live. Selfish motives certainly, but I could be independent, work any place in the world, with no time clocks, no desks, no commuting, and my only responsibility being to live as creative a life as possible. And not hurt anyone on the way. I somehow knew it would be rewarding in more ways than I could imagine. It was, of course, but how very naive we are in our early years. It's a blessing of youth. Otherwise, I'm sure we would perish in the labyrinthian quagmire of growing up.

I dropped my architectural studies and enrolled in the Art Center School (now The Art Center College Of Design) to study photography. I made it through the first four semesters before feeling I was being forced into a great funnel and would drop out that small opening at the end completely homogenized. I had had a lot of classrooms by then anyway, so I took what was to be a summer break. I went back to Europe to practice what had been preached to me in school. After only two months, I sold my return trip ticket and didn't come back until three years later.

It was an unparalleled experience. There was very little money changing hands (at least my hands), but what went through my head and my heart was invaluable. I made "Europe on five dollars a day" look extravagant. Youth Hostels allowed me to stay a night and eat for sometimes as little as $1.50 and love it. After a year or so, I did begin to make some money and my life began to change—it was never the same again. Regular meals were paradise, but a certain lifestyle was gone forever.

What I learned and came to appreciate about life, people, languages, food, and wine would fill a volume and, oh yes, I did take pictures. I practiced the preaching of schools, but learned the real lessons in application, plus a certain business sense. I had to keep food on the table, even if I didn't exactly have a table most of the time. In working, I began to develop a style. I began to see the design and graphics in all the things around me. It must have come from my love of architecture, but it was there and I applied it more and more frequently to any pictures I saw through the viewfinder. I was learning to see and even with the little money I had, I still put film through my meager camera system as often as possible. It was a learning tree with no comparison; no schoolroom can teach you what you learn in the field or on the road. I didn't realize then how important a style was to become, or what adaptability and innovation meant. I do now and am grateful that in the craziness of my youth some of that seeped in and stayed. In those beginning days, my direction was formed, my die cast, in the ambiance of Europe.

I could fill page upon page about cameras I used, jobs I did, lenses, filters and all the technical lessons, but some of that will come further along in the book. I received a technical base at school, but I learned photography through experience; by putting film through the camera, peering through the lenses, trial and error, and pondering every facet of light. It's the only way. If you think there is another way, or a faster way, write a book telling how and you will make considerably more money than by being a photographer.

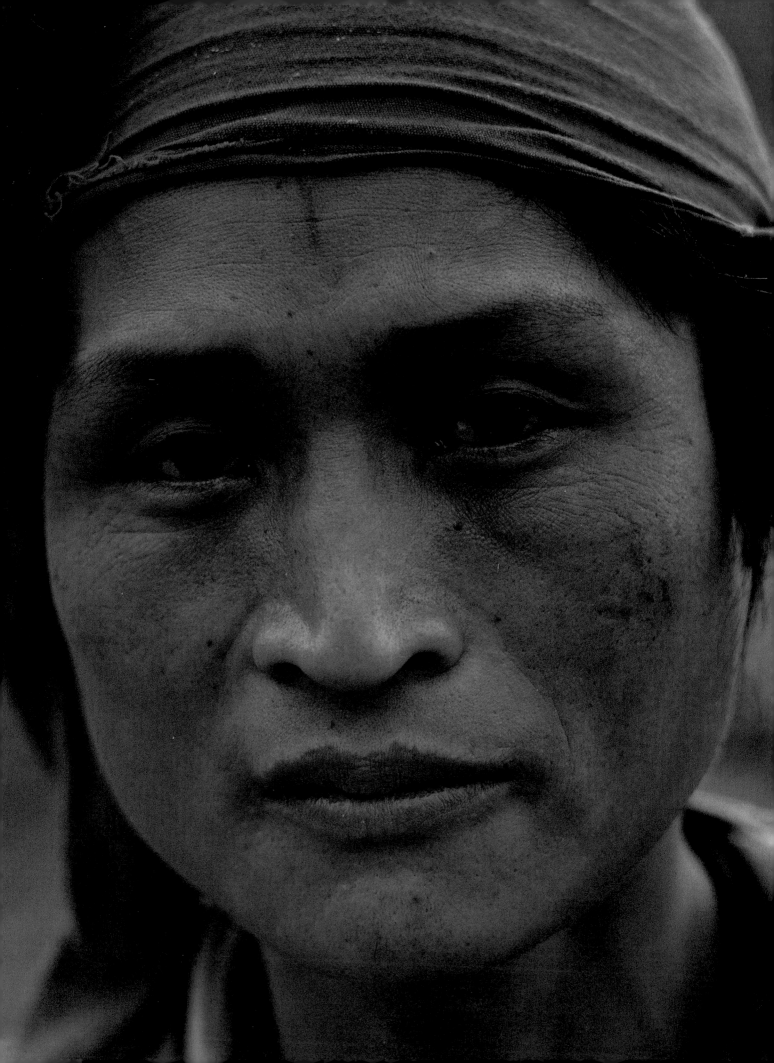

TRAVEL AND THE SCENIC

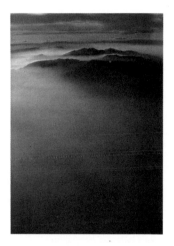

As photographers, many of us feel we are bound to record all we see, or at least try. But we are human beings first, and should be able to see all we've been offered. In the world of travel there are endless images and equally unlimited ways to see and record them on film.

I've started this book with travel because that's where it all started for me. Travel became a way of life for me at a very early age and it has allowed me to work all over the world. It afforded me a very modest income in the beginning, but I quickly found it cost little to wait for a sunset, or photograph a palm tree on the beach, or to work with models in exchange for pictures. There was so much imagery flooding my senses and it was only my lack of funds for film that limited my making of pictures. Most of all, travel showed me a wonderful and exciting world beyond my own and gave me the way of life that I enjoy today.

In my approach to a scenic, I always try to find what's already there that will work for me; something that will take the photograph out of the ordinary and make it special. That something almost always involves light and some design element within the scene. Design can manifest itself in countless ways; it could be a lone tree on the horizon, the angle of a rooftop, the way ridges of land line up in the distance, or the way an apple is cut.

I also look for color. That sounds obvious, but I mean that I look for a *kind* of color, either saturation or lack of it, which will take the scene to the monochromatic. I try to get whatever strikes me at the time about the scene working for me, accenting it or minimizing it.

It's almost always a momentary decision as things unfold inside that little 35mm frame that truly *makes* a photograph. These are things you will learn to recognize in time and to take advantage of within the context of the format you work with. No matter in what situation you find yourself, you will find a picture, somewhere. Just look for it, or make it happen the way you want it to. If you do it right, somewhere down the line, that picture will make you money, or hang on a gallery wall, or give you great pleasure in your own egocentric collection of "art."

Rio is simply one of my favorite places in the world. This picture was done on assignment for Travel & Leisure, and it marked the twelfth time I'd been to Brazil. There are some places in this world that you just keep going back to and Rio is one of them; Brazil is one of them. The time was dawn, which is the only time you can get this picture. The drive was a long one, up to Corcovado, and that morning I was alone on the peak with the great statue of Christ at my back. I was the only earthly creature to see that particular dawn from that very particular place. I'd never before seen that misty phenomenon gather around the peak of Sugarloaf, and I haven't seen it since. I captured a very special sunrise.

Pictures like these are rare and believe me, Rio has been photographed from this spot countless times. You are not always rewarded photographically for your efforts by Mother Nature, but being there that morning would have been enough. Had it been a century earlier I might have painted it. My feeling is: if you don't go, you get nothing. Sleep in and you get absolutely nothing. Make the effort and you will be rewarded in more ways than the photograph.

The Rio cover came out of the same incredible morning on Corcovado. Since I had covered the scene both vertically and horizontally it was ready, in format, for anything and was used for both. I suppose the magazine could have run a fold-out, double-page spread cover, but I don't think Adrian Taylor could have sold American Express on the idea.

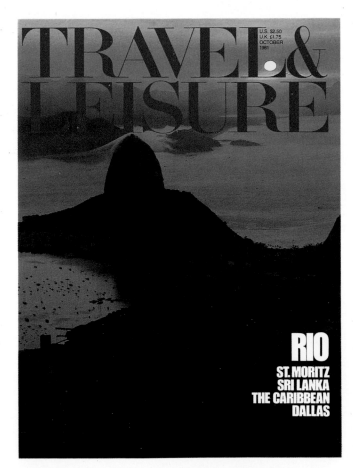

TRAVEL & LEISURE

U.S. $2.50
U.K. £1.75
OCTOBER
1981

RIO
ST. MORITZ
SRI LANKA
THE CARIBBEAN
DALLAS

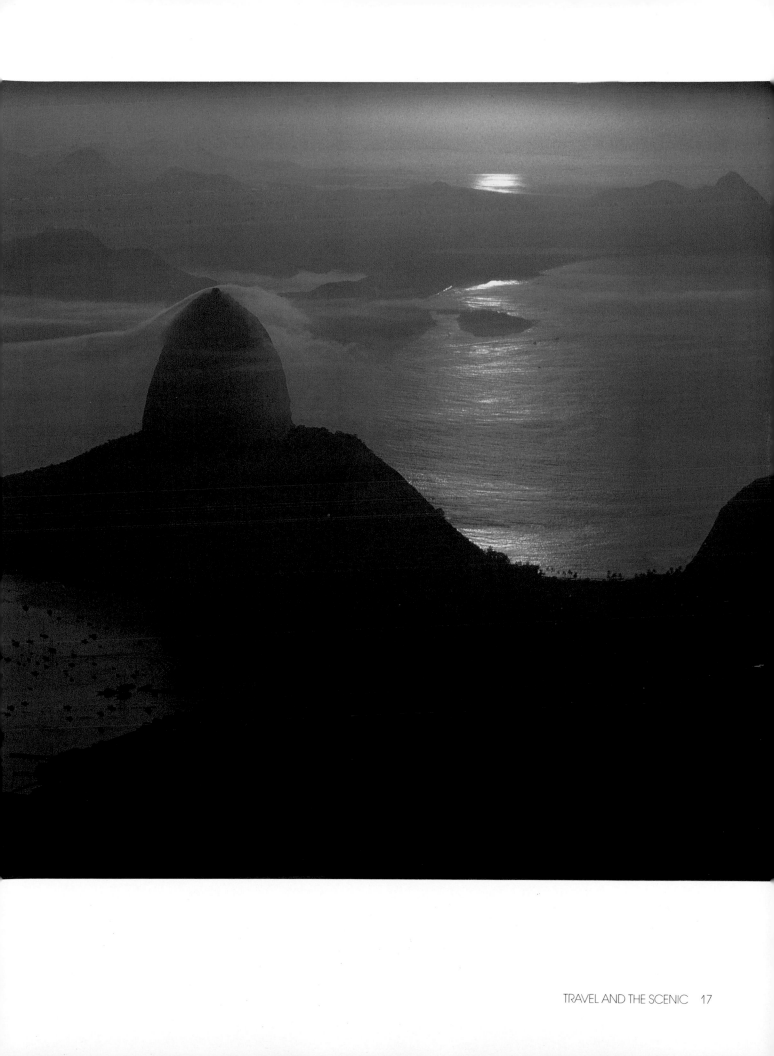

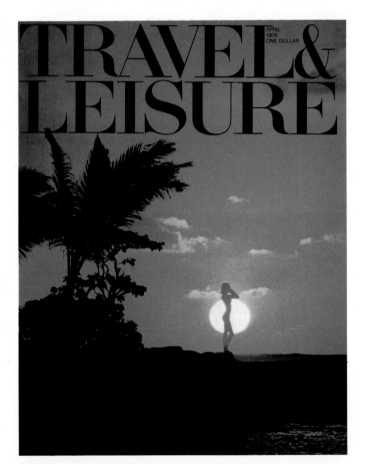

TRAVEL & LEISURE

THE HOT NEW PLACES FOR '86:
Sexiest Beaches in Brazil
America's Ritziest Ski Resort
World's Most Exotic Cruise
The Liveliest Part of Paris

WHERE TO GO NEXT

*O*n another trip to Brazil, again for Travel & Leisure, I was assigned to cover Buzios, the small fishing village Brigitte Bardot made famous in the Sixties. The cover came out of circumstance. I was on a planned shot with a lovely couple, when I saw this Brazilian fisherman idly paddling around on a windsurfing board. I saw the potential graphics of the picture and re-staged it as quickly as one can do anything in Brazil. It took about six seconds and fifteen frames. I didn't at all plan the shot for the cover. I had set up many other cover situations and selected even more from the general take on Buzios, but the Art Director, Adrian Taylor, liked this one, and we had a cover. A six-minute $1500; it pays to look around.

*T*he girl with the sun and palm trees was my first Travel & Leisure cover, so I hold it dear. On assignment in Hawaii, it was a set-up at dawn in front of the Kahala Hilton Hotel on Oahu. (One of the best hotels in the world, by the way.) I was out before dawn for two mornings, trying to get the right degree on the sunrise. The third morning was clear on the horizon and we got the cover. I went out a fourth morning at another location, but this one made it.

18

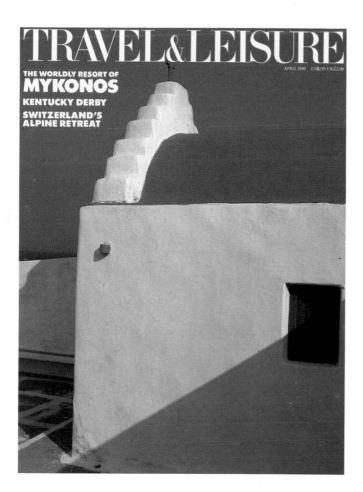

I happen to love islands and Mykonos is one of the best; and a crazy one at that—wonderfully crazy and very sensual, crammed with remnants of Sixties hippies and new hoards of Northern European tourists, hungry for fun and the sun. Believe me, they find it all on Mykonos. You may wonder then, why is a chapel on the cover if the island is so crazy? I asked myself the same question, considering the real make-up of the island, but this cover turned out to be one of the most successful for the magazine. It was an award winner.

But it's valid for the story because of the juxtaposition of the old and the new on Mykonos. The islanders live side by side with acres of bare-skinned bodies, both heterosexual and homosexual, from the world over. It's an easy place for a photographer to work; everyone wants their picture taken. When assigned a certain place, I always spend the first days wandering the streets and countryside just to get a feel for the area. I photograph at random; capturing vignettes and scenes that strike my fancy. These are pictures that can either fill a story, or make a cover. That's how the chapel made it; it was a long, hard drive and hike to find this little place as it appeared on the very inaccurate map, but in the end, it paid off. Again, being there was enough; I was the only human being in that spiritual place that early morning.

As a showcase for travel photography, Travel & Leisure is one of the finest. Fortunately for me, the magazine has been a client for a long time. I feel it is more a "family" than a client/photographer relationship. I've known Pamela Fiori, the editor, and Adrian Taylor, the art director until 1986, for an equal length of time—Pam since she first worked with Frank Zachary at the original and great Holiday magazine, and Adrian since he was an art director in San Francisco.
The freedom they have given photographers is a double-edged sword, because they must bring home the goods with little or no excuse for not doing so. There are no excuses for weather, war, plague, pestilence, bad labs, X-rayed film, a dying aunt, a missed plane; forget it, you have to get the picture. And, when you think about it, there really is very little reason not to come back with the goods. Looking back, I cannot remember when I didn't get what was needed. There were certainly better trips, better pictures than others, but a "pro" gets the job done. That is the single reason he is hired so much more often than the new kid on the block. The "pro's" vocabulary does not include the word "can't." An editor has a good deal more on his mind than having to worry about a photographer assigned and already on the plane; there is always next month and that comes around awfully fast indeed. I've always been thrilled that I'm not in the office having to face that monthly deadline.

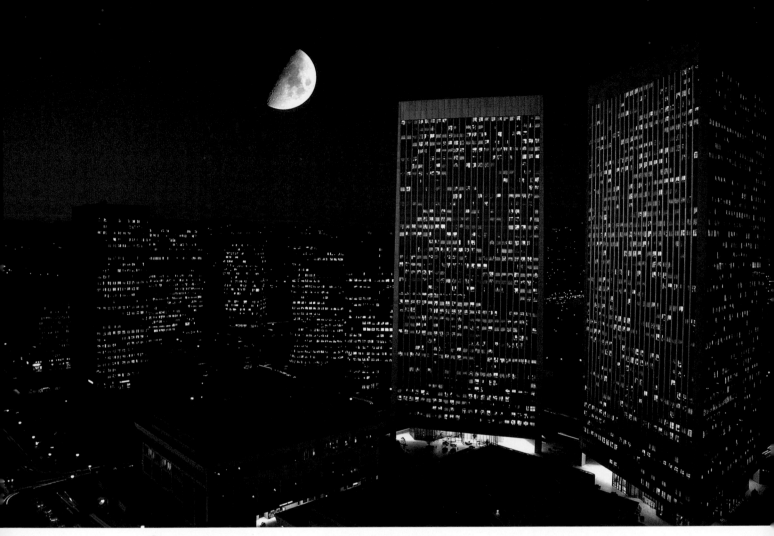

On travel assignments, you are almost always going to be faced with some architectural coverage, whether it be a small fisherman's cottage or the complexity of a city center. To do any architectural work with 35mm cameras takes some special considerations. It's important to keep your verticals vertical unless you use an extreme, upward angle. This eliminates the horizon, which gives the picture drama beyond the ordinary. If the horizon is in the frame, the rule is to keep thinking level and vertical.

Following that line of thought, to keep a skyscraper straight, you'd better be up off the ground yourself or you will have a lot of foreground to contend with. Finding something to fill the foreground of a photograph like this is another answer to dealing with the problems of shooting architectural with 35mm. In this case, I moved upwards.

This photograph of Century City in Los Angeles was taken from the Presidential Suite in the tower of the Century Plaza Hotel across the street. The suite

was to be closed two days later for security reasons due to an impending Presidential stay. We had been waiting for the right weather for days and finally had to schedule the shot; we got lucky with the sunset. I added a .20 magenta filter and double-exposed the half moon hanging over my shoulder into the overall scene. It's a little too big to be "right," but it gives the picture a slightly mystical quality that's certainly LA, right? The moon was exposed on a 300mm and the city on something much wider.

I've said before that I see design and graphics in all things. Here are three illustrations that show the design present in man's footprint on the world. The dark object in the tower shot is a very large ocean buoy, used as decor at the El Presidente Hotel on the island of Cozumel, Mexico. It was in shadow, dark to begin with and the deep exposure on the sky made it a completely black, inanimate object giving some pretty fair drama to an ordinary situation. The picture was done on assignment for Esquire a long time ago, before there was a single hotel at Cancun. The buoy is also gone from the El Presidente; times and places change. Hopefully, we keep pace.

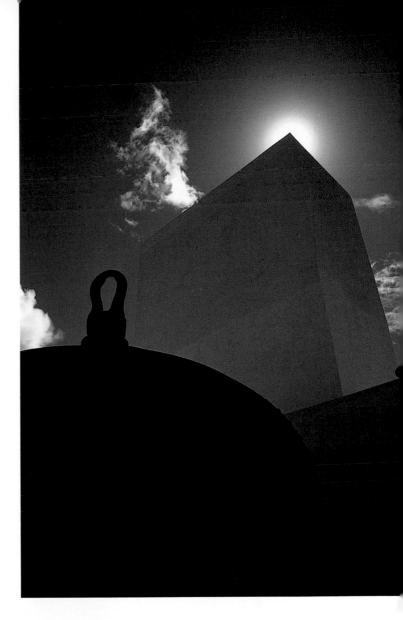

I love arches, and these speak for themselves with regard to graphic design. I waited for what seemed to be hours for a hooded nun or priest, a dog, or anyone to pass through the arches, but it was to no avail. I like the simplicity as it is. With a figure it might have been a cliché. The place is in San Juan, Puerto Rico, on assignment for Commodore Cruise Lines.

OVERLEAF

This was also in Old San Juan; the blue paving stones have fascinated me for years. They are wonderful. I sat on the stones, again waiting for something, anything to "make" the picture. Incredibly, a girl came by with blue shoes. (Although I would have preferred red.) In my very rough Spanish, I asked her to walk by me several times. She certainly thought I was crazy, but she did it. While I was doing all this waiting, I picked out tons of debris from between the stones to clean up the pictures. Several passersby, all with the wrong shoes, probably thought I was a madman with a brick fetish. Someday I'm going back there with red shoes.

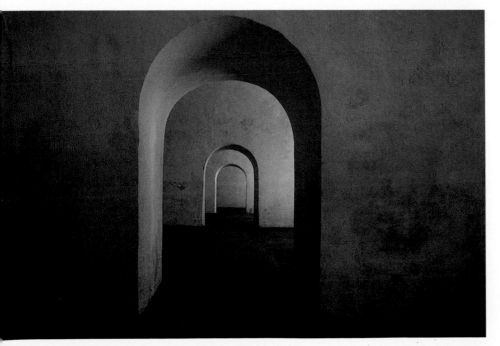

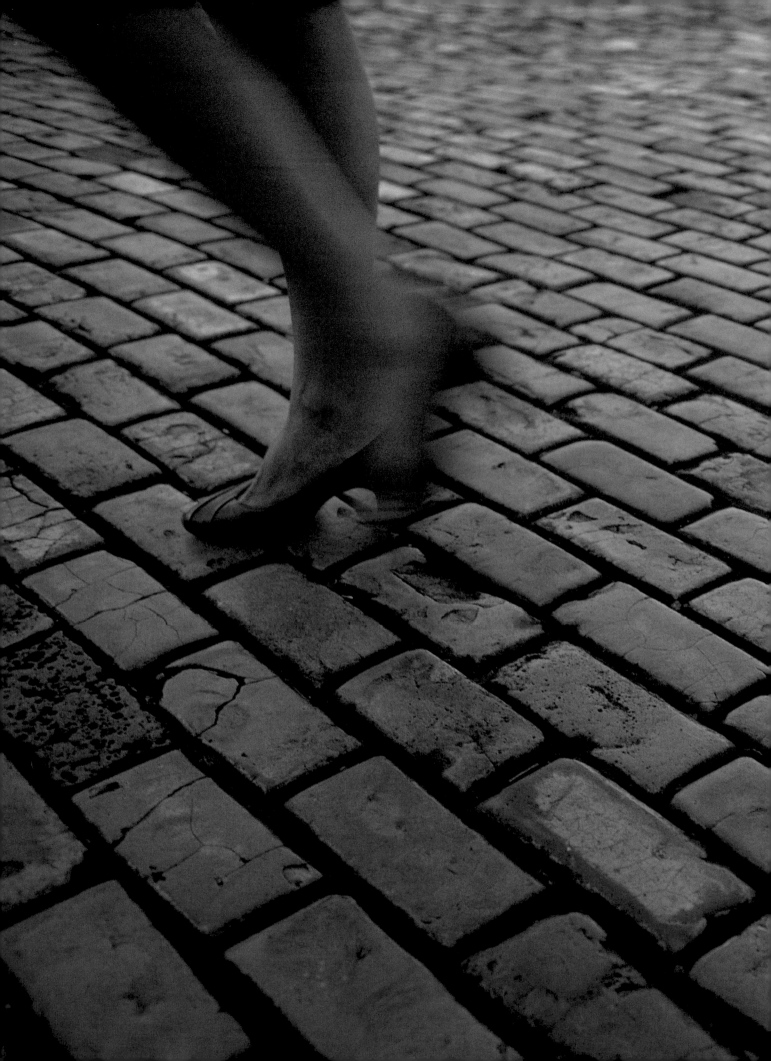

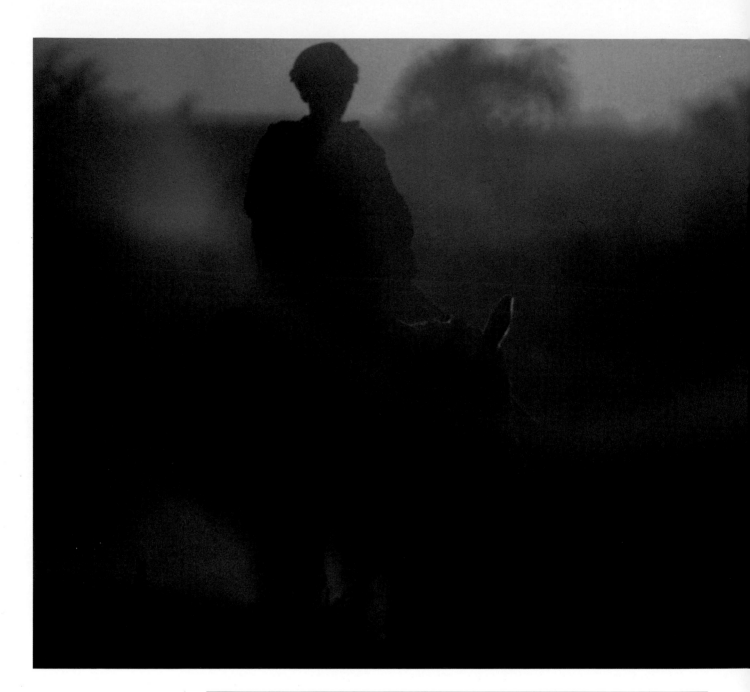

While traveling the world, if you say you are going to send a picture, please send it, no matter what. If you don't intend to send the picture, please don't say you will. I meet so very many people around the world who tell me of promises made by photographers that have not been fulfilled. I know exactly what the thoughts of these "gentlemen" photographers are: "I'll never pass this way again. So what?" You made a promise, that's what. Some may actually just forget, but I don't buy that for a minute. How can you forget while you sit at a light box and review all the scenes from an incredible trip? It doesn't compute. Remember, what is only a small 5x7 and incidental print to you, may be something of value to a small child in the far reaches of the world. I've sent prints to the most remote places imaginable and received primitive, but wonderful, thanks in return. I even have a great "pen pal" in Bhutan and we've communicated for years.
My address book is world wide and growing.

The man on the donkey was photographed in Morocco while I was on a sort of sabbatical from cities, advertising, and the general "normality" of my everyday life. I was making my first film documentary, but was still essentially a still photographer and could not resist using my Nikons. I even converted my Nikkor lenses to fit the film cameras. This picture was taken with the 500mm mirror Nikkor, brought along on that trip for its size, weight, and convenience. It's a good lens but sometimes tough to use with its fixed aperture.

I didn't consider working into the sun or the resulting flare a problem and it works in this case, at least for me. But perhaps that's one reason why this picture has never sold. The other reason is certainly because it's been hidden in my files as a "favorite" and a showpiece for ten years. (This is definitely not a way to make money on pictures!)

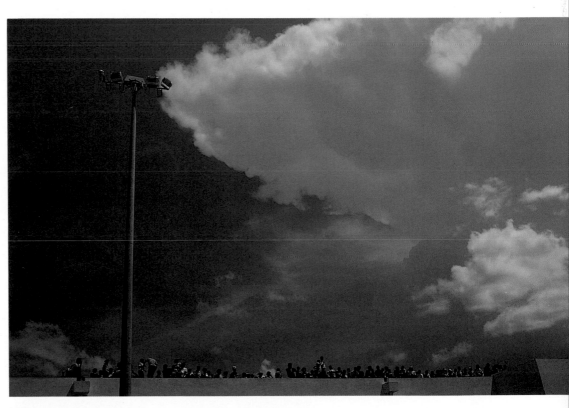

While on assignment for Commodore Cruise Lines in the Caribbean, I was waiting to take off on the chartered plane hired for the job. I noticed that several hundred Jamaicans were also waiting. They were on the roof of the airport with that super sky above them to give the scene contrast. The rest was made up by whoever is in charge of the human phenomena. Never being one to sit idly by when a photograph is literally put in my lap, I exposed about a roll of film, vertically, horizontally and whatever way it composed well. It seemed better than just sitting, as I've seen many photographers do on more than one occasion. I simply cannot pass up a possible picture; it is not in my make-up. Many times I've been absolutely exhausted after a day of work on location and still gone out at sunset.

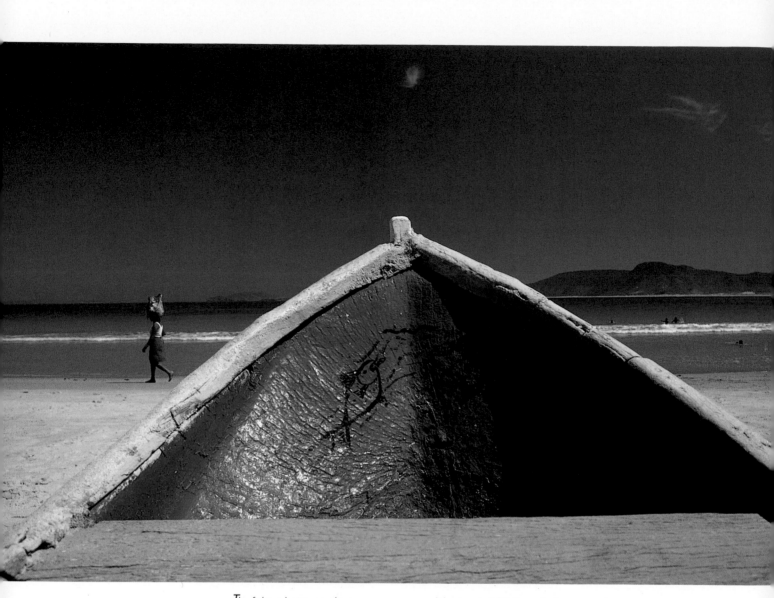

The fishing boat was there on the beach in Buzios, so I had more control and put the shot together. In this case, the middle of the day worked best for the color and contrast. Once the shot was set and after I ex-posed the scene, I felt it needed the human element. I found a woman down the beach and asked her to do the walk. Travel & Leisure used it as the opening piece for the story on the famous village.

The human element. People are what make pictures tick in most cases. You can only look at so many scenics and then you begin wondering if the earth is inhabited. It is, of course, and with some wonderful people. You find them in the most remote places, living in a variety of ways that are staggering compared to America.

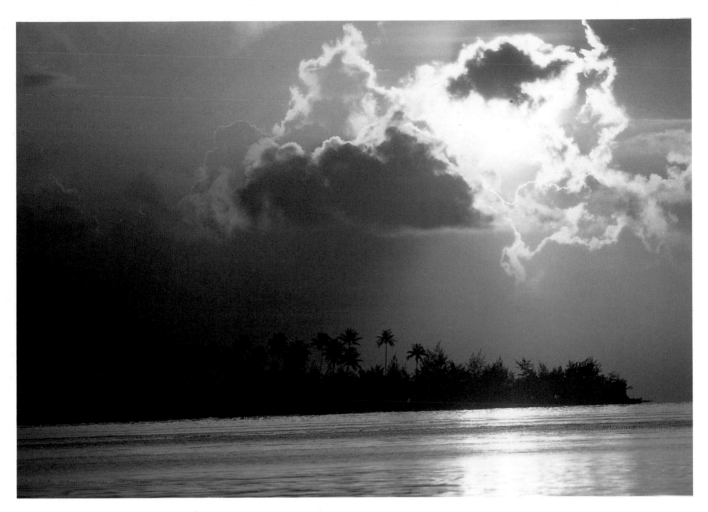

I honestly cannot remember a sunset I didn't like. They are all very special occurrences. After all, there will never be another June 14, 1986—on the island of Bora Bora, no less. I wasn't *on assignment, but the opportunity was there. This picture will sell long after I'm gone and for as long as the physical ingredients of the transparency hold together.*

There isn't much time when the sun is on its last run to the horizon. Using two cameras will maximize your chances of getting more than one dramatic picture with one lens. Changing lenses while the sun sets will lose you a good many pictures. And a sunset doesn't happen the same way twice; coming back the next day might not net you the same payoff. When it happens, do it the best you can. Don't get me wrong, it's not a sin to get it on one camera and one lens. The point is to be there, camera or not. Get it on film, or in your head and heart. It will make you a better photographer and, as the cliché goes, it will make you a better person. I believe that.

The river is the Danube, the beautiful blue Danube. Budapest is a wonderful city with the river dividing the old city of Buda and the newer side, Pest. The Chain Bridge is one of many bridges connecting the two. When the sun leaves the scene, it turns dark very quickly and exposures lengthen considerably. This picture was exposed at about 15 to 30 seconds, including compensation for a 20B and 10M filters. I made it blue, as it's really not quite that color. The actual sunset and residual light were extremely gray and I felt the filters would help the color and heighten the mood of the blue Danube. It took two days of scouting, (along with doing other pictures,) to find the right building and get permission to take this photograph. I think it was worth it.

Twilight in the cities—always a dramatic way to portray these big concentrations of mankind. This time of day and type of light covers a multitude of sins.

The warm sunset over Acapulco was photographed from my hotel terrace and it happened as seen; no special filters, lenses, or manipulation. The time was about ten to fifteen minutes after a hot Mexican sunset and the color had just begun to appear. Waiting a bit longer would have given a more even exposure between the city and that sky, but I felt the sizzling horizon was right for Acapulco. If you've ever been there, you understand.

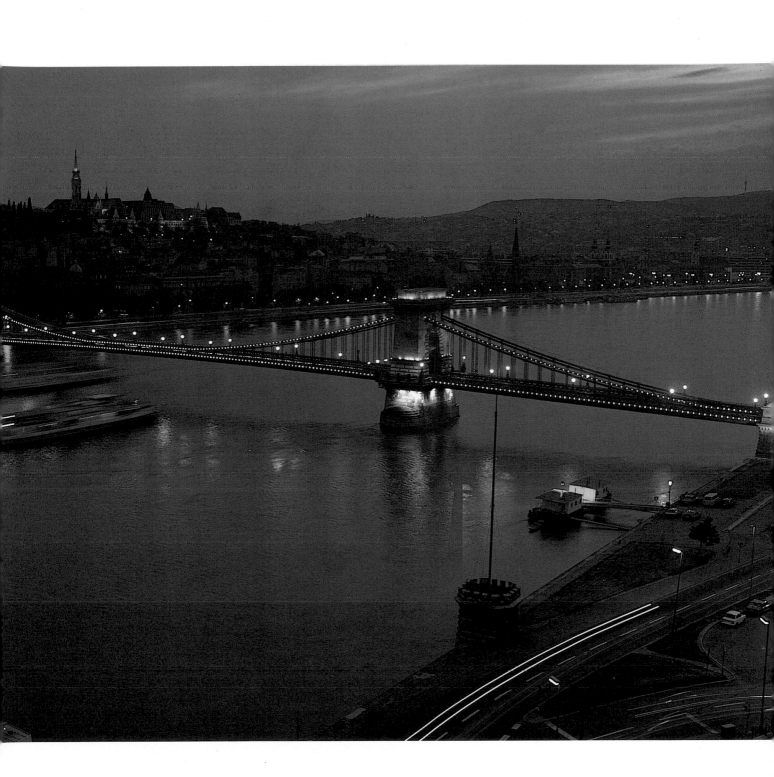

I have always felt that if a photographer makes the effort to be there at dawn or dusk, or anywhere for that matter, he or she will almost always be rewarded. After making the effort, there have been few times I came back empty handed, either with exposed film or a better feeling in my heart. Many times I've gone to the potential location well beforehand to make sure it's right, especially if I plan to photograph at dawn. I do not want to be stumbling around in the dark while the best early sky is approaching. You have to be set, more so than at dusk. It seems to happen faster in the morning. I don't know why, it just does.

I spend a great deal of time on jets and I have never tired of gazing out those little windows on the world. A great many people, including photographers, sit for hours, oblivious of the panorama outside those portholes in the sky. Perhaps I'm still a little boy in many ways; the difference now is that time and toys cost more money. I don't always just look at the view; I try to put it on film. There's a good chance I have sold more photographs taken out of a jet window than most other people in this business. I'm also on many small planes and helicopters, which adds to the potential.

This picture was taken enroute to Cabo San Lucas, Baja California. The land mass is the Baja Peninsula, the time is sunset. Most often either the 35mm or 85mm lens does the job, but I experiment with all sorts of lenses and filters for these pictures. Besides, I'm working through two layers of airplane glass to begin with, so I never know exactly what I'm going to get. That's part of the excitement: those first moments at the light box opening those ever-present little yellow boxes. In this case I used a combination of an FLB and a .20 magenta filter. Airplane pictures may have limited use or sales, but they are fun to do and stretch the imagination a bit on a long flight. I just like making pictures and this is one more opportunity.

This is one of my favorite "porthole" photographs. I made it straight from the hip, with no filters, and it has sold many times. I photographed this snow field during a flight on the polar route to Europe. For some reason, the pilot was at a particularly low altitude and the day was crystal clear. The lonely and desolate polar region was so fascinating, it made me wonder how something so beautiful could be so inhospitable and take the lives of many who tried to cross it and explore. I've never been on a flight like that since. Once again, not only being there but taking advantage of it made the difference. I think all but a very few passengers noticed or cared about what was going on below. It was and is always a rather sad revelation to me.

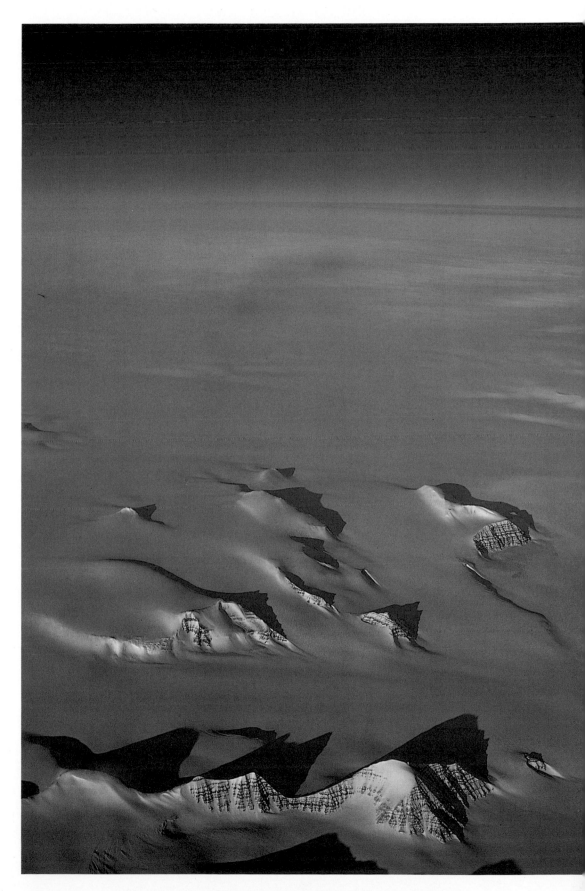

EDITORIAL

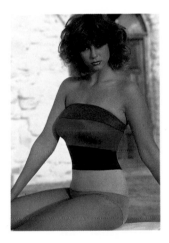

For the most part, I consider editorial to be the purest use of pictures. Specifically, these are pictures that are going to be published, used on the printed page. Taking it one step further, the ultimate purity would be fine art and the gallery. However, it's difficult to make major money on photography as fine art, unless you are either in the grave or close to it. Editorial is a more than acceptable interim. It is in fact, the best way to show your work and reach the greatest audience. It's being paid to present your portfolio. Many times it involves extensive travel and some editorial photographers are gone more than they are home. You can make a very good living with the magazines, but it is a matter of keeping very little overhead at home. In my situation, I've combined editorial and advertising over the years and it has worked very well—for me. My studio and office have been in my home for the past twelve years, so my overhead is not as great as it might be for others in the advertising trade.

Freedom is probably the greatest joy in editorial photography. You are usually on you own; no art directors, no account people, no clients. This can be a euphoric, rarefied experience, but, it can also be fraught with dangers. It is really a two-edged sword. You have to perform; there are no excuses and no one to cast blame on but the photographer.

Magazines also give you nice big pictures, although this is more true of European publications. Don't let anyone fool you, a big picture is always better than a little one, and a spread is always better than a single page; we photographers live for the spread. Nine times out of ten, there is little or no type over your photograph. There it is, in all its purity and strength of statement. It rises or falls on its own merit. No wonder a good many of us scramble for those pages and are willing to work for almost nothing to get them.

Perhaps I neglected to mention that magazines do not pay very well, some as little as $150 per color page. Of course some pay higher, but the limit is about $600. Remember though, many times there is more to taking photographs than the money. Ten pages in a good magazine can be the best promotion you will ever receive and most of all, it rubs your ego the right way. Sometimes you have to do pictures for yourself and editorial is just about the best way I know of accomplishing this.

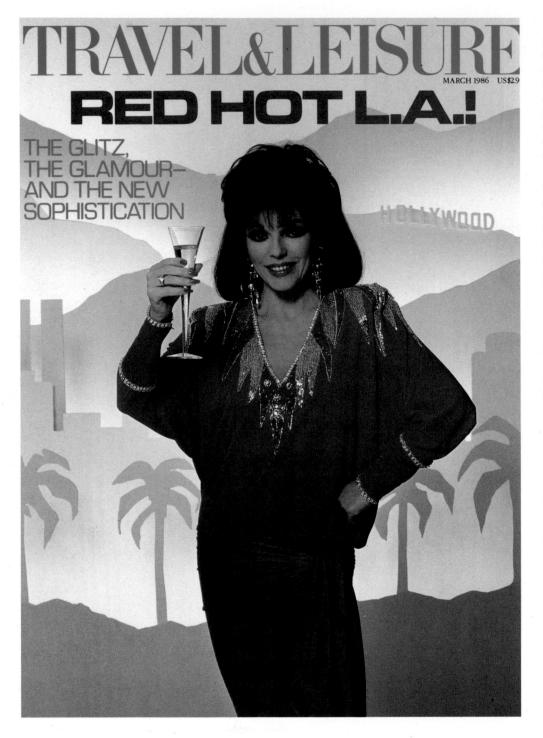

TRAVEL&LEISURE

MARCH 1986 US$2.9

RED HOT L.A.!

THE GLITZ, THE GLAMOUR— AND THE NEW SOPHISTICATION

HOLLYWOOD

To be given the entire issue of a magazine connotes a good deal of faith in the photographer by the editors of that magazine. Travel & Leisure exercised that faith by giving me their entire Los Angeles issue to do on my own. It was a very exciting challenge because it was more than just doing "snaps" of the city. The assignment would involve extensive production including restaurants, portraits, and working with celebrities, which sometimes is not all that easy. It took two very hectic months and then some. Taking the pictures was the easy part; producing them on schedule was considerably more difficult.

The art director at that time at Travel & Leisure was Adrian Taylor and the double-page spreads you see here and on pages 36 and 37 opened each section of the issue. They illustrate what I mean about going for a big picture. When one works on editorial there are several things to keep in mind. One is to search for cover possibilities, the other, when applicable, is to allow for headings and type wherever possible. It worked here in most instances. Seeing the spreads side-by-side gives you an example of how much more impact they have over the single pages.

I've always tried to stress the learning process of putting film through the camera. Editorial is wonderful in that respect. I learned more about Los Angeles than I ever thought possible; I met many people, discovered wonderful restaurants, and saw the city in a new light. I think one often takes the place they live in for granted. Working for magazines, especially if you are fortunate enough to travel while doing so, is one of the greatest classrooms on earth.

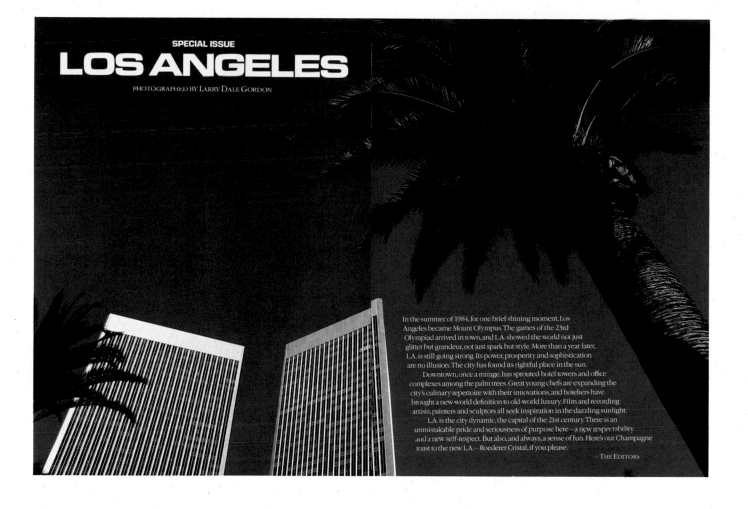

SPECIAL ISSUE
LOS ANGELES
PHOTOGRAPHED BY LARRY DALE GORDON

In the summer of 1984, for one brief shining moment, Los Angeles became Mount Olympus. The games of the 23rd Olympiad arrived in town, and L.A. showed the world not just glitter but grandeur, not just spark but style. More than a year later, L.A. is still going strong. Its power, prosperity and sophistication are no illusion. The city has found its rightful place in the sun.

Downtown, once a mirage, has sprouted hotel towers and office complexes among the palm trees. Great young chefs are expanding the city's culinary repertoire with their innovations, and hoteliers have brought a new-world definition to old-world luxury. Film and recording artists, painters and sculptors all seek inspiration in the dazzling sunlight.

L.A. is the city dynamic, the capital of the 21st century. There is an unmistakable pride and seriousness of purpose here—a new respectability and a new self-respect. But also, and always, a sense of fun. Here's our Champagne toast to the new L.A.—Roederer Cristal, if you please.

— THE EDITORS

If you know how a magazine is apt to use photography, you can dictate, through the execution of your pictures and your editing, how they show your portfolio. Editing is extremely important and if you don't want to see it published, don't put it in your edit. It's as simple as that. There is no explanation for the picture choice made by art directors and editors; it is one of the greatest mysteries in this business. You will never understand why they pick the pictures they do. However, you must remember that they were not there; they do not have the same emotional attachment to the photograph that you do. Editors must look at your work from a very objective point of view. They have to tell the story and if a picture works or doesn't work, it will be used or tossed on that basis. Some art directors like to work with as few pictures as possible; they want your edit. Some want to see every frame you've exposed, the good and the bad. Very insecure on their part, but a fact of life. You will find this true more often in advertising than with the magazines, but try to fight for your edit as often as possible. There's an old story in the business about photographer Guy Bordin, who reportedly gave a major client one transparency after taking weeks, at great expenditure, to do the job. The client was furious. Bordin picked up his transparency and left the room. A great artist, but not a very good businessman. Unfortunately, we all have to make a living, so you have to find a balance that's right for you, a place where you can live aesthetically, but still make the profession you've chosen give you a lifestyle to which you want to become accustomed.

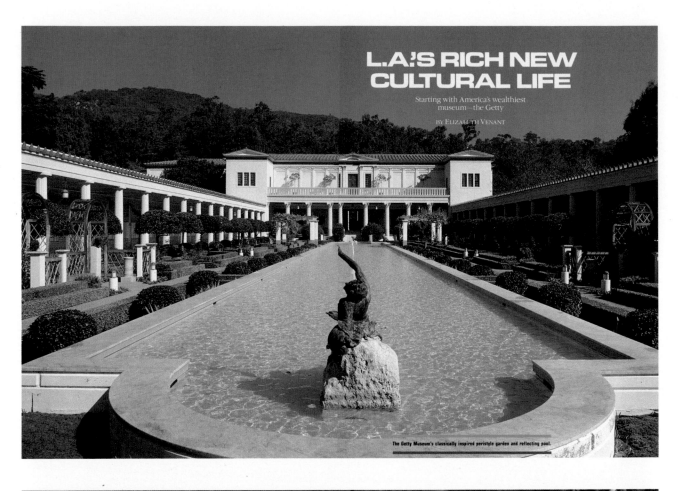

L.A.'S RICH NEW CULTURAL LIFE

Starting with America's wealthiest
museum—the Getty

BY ELIZABETH VENANT

The Getty Museum's classically inspired peristyle garden and reflecting pool.

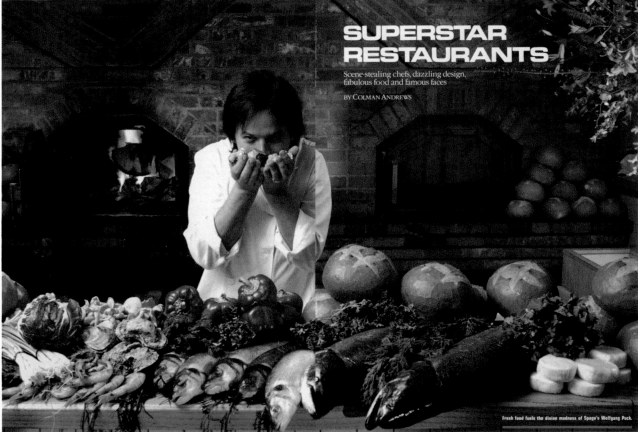

SUPERSTAR RESTAURANTS

Scene-stealing chefs, dazzling design,
fabulous food and famous faces

BY COLMAN ANDREWS

Fresh food fuels the divine madness of Spago's Wolfgang Puck.

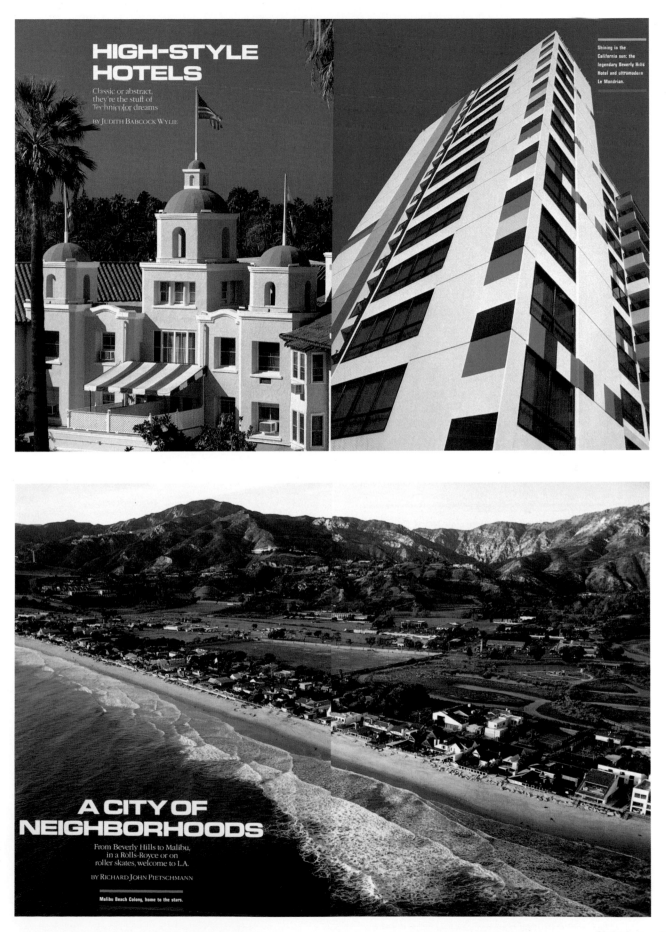

HIGH-STYLE HOTELS

Classic or abstract, they're the stuff of Technicolor dreams

BY JUDITH BABCOCK WYLIE

Shining in the California sun: the legendary Beverly Hills Hotel and ultramodern Le Mondrian.

A CITY OF NEIGHBORHOODS

From Beverly Hills to Malibu, in a Rolls-Royce or on roller skates, welcome to L.A.

BY RICHARD JOHN PIETSCHMANN

Malibu Beach Colony, home to the stars.

Frank Zachary, the editor at Town & Country, is one of the giants of design in this business. Is my audience old enough to remember the magazine Holiday? I was fortunate enough to work for him briefly then, and have since. I hesitate to tell you how long ago it was, but suffice it to say, Holiday was a great magazine in the tradition of large format, bold layouts, and big pictures—and they sent you places. At today's costs for the mail, printing, paper and unions, it's very difficult for magazines to function in the same way, even if they are owned by corporate giants. Zachary has now been with Town & Country for many years, and has made it into a money maker for the Hearst Corporation, as well as a showcase for his photographers. At his side laying out the magazine is art director Melissa Tardiff. Working with him and for him has always been a great pleasure.

Zachary sent me on a gem of an assignment to Cabo San Lucas with Rachel Ward. It was also a great opportunity for my then assistant, Michael Purcilly, who ended up being the model/"playboy" character in the pictorial. The story was a funny one about a playboy fishing for and trying to win a mermaid. Zachary wanted the prize to be a fish (because mermaids eat fish). After the would-be lover had tried everything from the Mona Lisa to jewelry and furs, he wins with a mackerel. I hated the fish idea and didn't use it, opting for flowers. Zachary won in the end by putting the fish in the flowers by retouching.

We photographed Rachel in almost all direct sun. I think it had to do with being in Cabo San Lucas; the place is bathed in heat from a sultry sun, and tequilla abounds. In all these pictures, the lighting could not be more simple, coming from a relentless source that will almost never fail. The only filtering I ever use, unless there is a special need, is the Singh-Ray CEF 40-T, which is specially designed for Kodachrome 25. The filter gives the skin a warmer glow and is applicable to all situations, even scenics.

Town & Country March 1979 © The Hearst Corporation

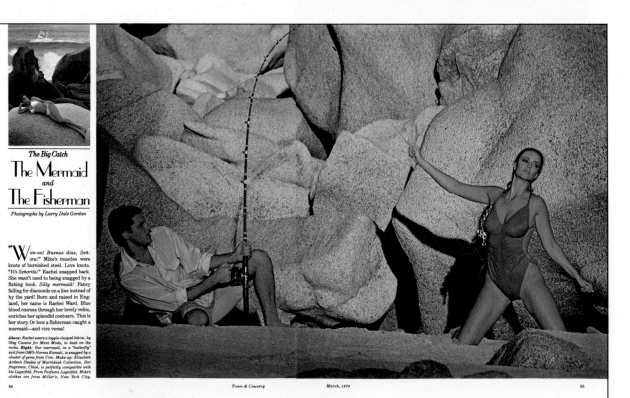

The Big Catch
The Mermaid
and
The Fisherman
Photographs by Larry Dale Gordon

"Wow-ee! *Buenos dias, Señora!*" Mike's muscles were knots of burnished steel. Love knots. "It's *Señorita!*" Rachel snapped back. She wasn't used to being snagged by a fishing hook. *Silly mermaid!* Fancy falling for diamonds on a line instead of by the yard! Born and raised in England, her name is Rachel Ward. Blue blood courses through her lovely veins, enriches her splendid contours. This is her story. Or how a fisherman caught a mermaid—and vice versa!

Above: Rachel wears a toggle-clasped bikini, by Oleg Cassini for Mara Moda, to bask on the rocks. Right: Our mermaid, in a "butterfly" suit from OMO-Norma Kamali, is snapped by a cluster of gems from Ciro. Make-up: Elizabeth Arden's Shades of Marrakesh Collection. Her fragrance, Chloé, is perfectly compatible with his Lagerfeld. From Parfums Lagerfeld. Mike's clothes are from Miller's, New York City.

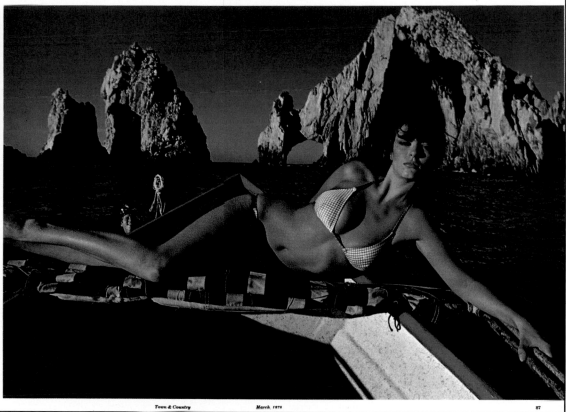

Rachel, a noble maid, lists earls and countesses as forebears but she couldn't abide the idea of *another* English winter. What she needed was a good frolic. Poolside, at the Beverly Wilshire Hotel, was nice, but confining. So she hopped a plane to Baja California, *terra incognita,* Mexico! At the end of the line, or the peninsula, there's a delicious hideaway, called Cabo San Lucas. The Tropic of Cancer courses under foot and under water. To the East there's the Sea of Cortez. On the West, the mighty Pacific. Rachel bathed, cavorted, frolicked. Great marlin sped through the water. Splendid fishermen pursued them—including Michael Purcilly, racing driver, surfer, all-American *dreamboat.* Upon first sight of Rachel his eyes misted over. He tried to tempt her with handfuls of precious jewels. She turned her lovely back on him. "Dinner, tonight?" he hollered. "Jolly idea!" She gave him a sidelong glance thinking—I'll have a nice piece of fish and get to bed early!

Above: Looking longingly seaward, landed mermaid Rachel wears a cowled bikini, from Cole of California, and necklace, both designed by Bob Mackie. Right: *Not tempted by the frogman's sunken treasure of pearls from Tiffany, Rachel sulks and suns in a Cole of California string bikini. Gold cuff by David Webb. Make-up from Lancôme's French Impressions. Her fragrance is exotic Fidji.*

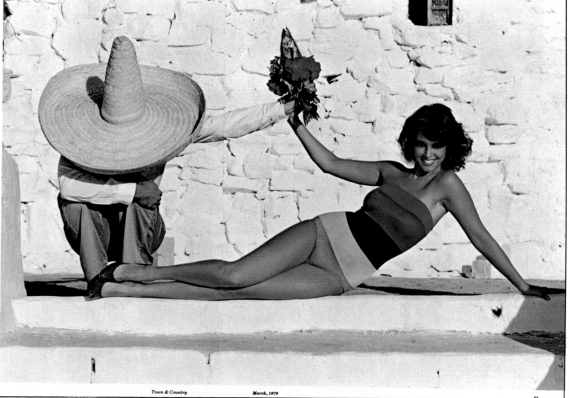

"You're sweet!" Rachel's eyes were charged with enough kilowatts to keep Con Edison clear of all future blackouts. It was love! What's more, it was that particular form of love some women feel for large men, and mermaids for fishermen— that is, *protective.* As for Mike, uncertain of her emotions, he had gone off to consult the local Hex—or shrink, or M.D. "I'm in love with a mermaid!" He told him. "British to boot!" The Hex looked quite pensive. Of course, he was Mexican. Most Mexicans are apt to look pensive. "Feed her fish!" he said, "And give her this magic bouquet of oleander and maiden's breath. It's self-renewing." The Hex then added, "But she must love you as much as you love her. A thousand pesos, *por favor!*" Rachel doted on red snapper. No sooner had Mike given her the Hex's bouquet of oleander and maiden's breath than *Bingo!* Out popped a red snapper. Rachel's eyes, and her smile, almost caused a blackout in Cabo San Lucas. She was one happy mermaid!

Above: Mermaid-turned-beachcomber, in a snappy plunging Danskin swimsuit. Earrings by Helen Woodhull. Hat by Stuart Jay. Right: *Flowers and fish, the perfect bait for a sea nymph! She wears an electrifying maillot from Capezio Ballet Makers. Shoes: Charles Jourdan. Make-up from Estée Lauder's Patchwork Quilt Colors. Her Estée Daytime fragrance mingles deliciously with his Aramis cologne.*

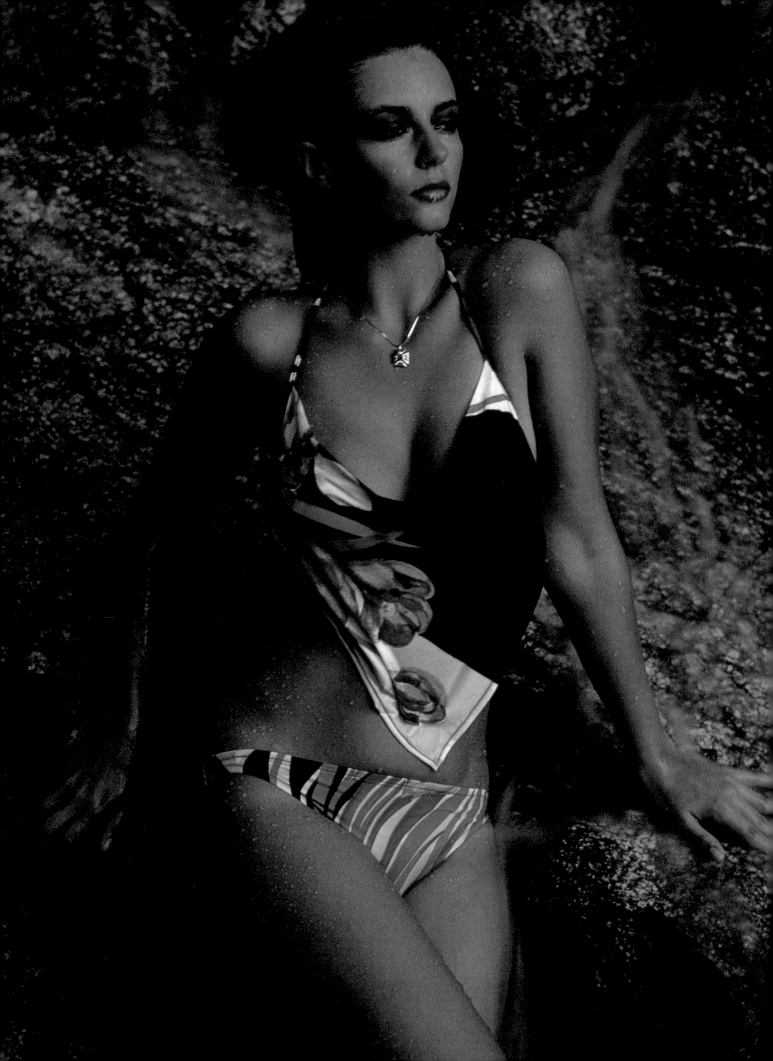

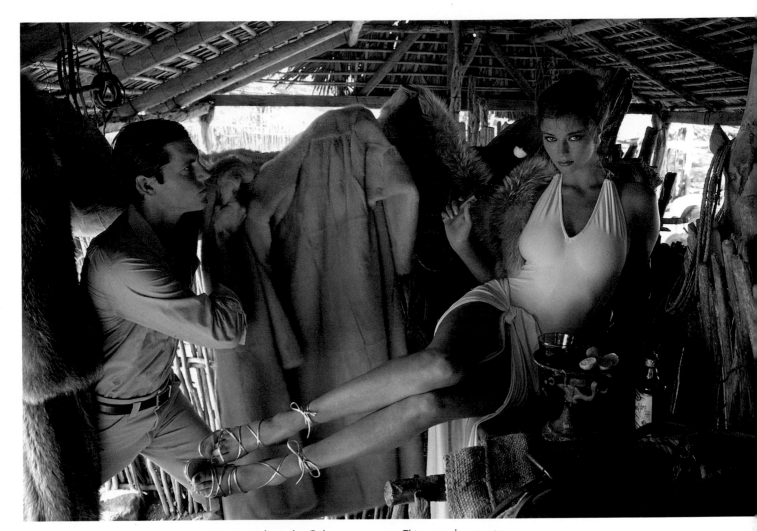

Locations abound in Cabo San Lucas and we tried to show the place while keeping the photographs graphic so Rachel would be the focus. We also went for the big picture, knowing the magazine and what Zachary liked to use. There were many verticals and lovely pictures of Rachel, but the spreads have impact. The exception might be the bathing suit shot on the left, which is one of the sexiest pictures I've ever seen. This was a beauty story and included jewelry, make-up, perfumes, and bathing suits, but the real story was on Rachel Ward. She went on to become an actress of note, marry Brian Brown from Australia, and begin a family. She's lost weight and will probably hate me for publishing these pictures, but Rachel, as you are beautiful now, you were beautiful then; a truly magnificent and lovely woman.

This fashion piece was done for Playboy, again in Cabo San Lucas, at the Hotel Cabo San Lucas with John James and Kathleen Beller of "Dynasty." They were great fun to work with and easy to be around, which, as I've said before, makes a difference.

The action shot was predicated by the Cabo San Lucas surf and Kathleen made a great leap; her timing was right and we got the picture—there was only one.

Experience with a location and the light available will help you in ways no school could ever hope to. When you work in an area, really look at it, make notes if you have to, put pictures in a book if you have to, but remember it and file it away in the corners of your mind. It may save your neck someday.

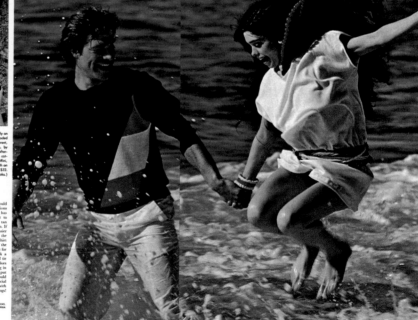

GET OUT OF TOWN!

for a midsummer break, playboy gets away to it all with "dynasty" stars john james and kathleen beller

attire By DAVID PLATT

Above: John James and Kathleen Beller of ABC's Dynasty head down Baja way; his choice of casualwear includes a cotton/polyester shirt, by Robert Bruce, about $24; and cotton twill walking shorts, by Fagonnabile, $65. (Kathleen's shirt and shorts by Tesso.) Above right: A waterside amble and he's in his traveling clothes—a polyester/cotton suit, by Adolfo for Leon of Paris, about $225; plaid cotton/polyester shirt, by Gant, about $27; and silk tie, by John Henry for Manhattan Accessories, about $15. (Her dress by Carole Little for Saint Tropez West.) Right: For the cool of the evening, James chooses a polyester/rayon jacket, by Andiamo, Ltd., about $100; cotton wing-collar shirt, by Henry Grethel, $40; and bow tie, by Liberty of London, $11.50; combined with his suit pants. (Her Victorian skirt and blouse by Sermoneta.)

WHEN THE SUN goes down and the tempers and the tantrums come out at the Carrington mansion on ABC's superhit Dynasty, it's time to get smart and get lost—as two stars from the series, John James and Kathleen Beller, have done here. (In case you've spent the past year in a cave, James plays Jeff Colby, who was formerly married to Blake Carrington's daughter, the ferocious Fallon; he's now married to the luscious Kirby Anders, played by—you guessed it—Beller.) When choosing what to take for a long-summer-weekend getaway, do as James has done and pack a minimum wardrobe that will give you maximum mixing-and-matching mileage. Whether you're heading just across the state or all the way to Baja California's Hotel Cabo San Lucas—where we shot this feature—one garment bag for a jacket and shirts and one

PHOTOGRAPHY BY LARRY DALE GORDON

Above: For an afternoon that's happily on the rocks, James has packed a hooded nylon windbreaker, by Yves Saint Laurent, about $30; plus nylon swim trunks, by Daniel Axel, $16. Right: As an after-summing cover-up, he's switched to a cotton knit crew-neck, by Gianfranco Ruffini, about $55; and cotton twill slacks with an elasticized waist, by Sweats bi abe, $32. (Beller's belted dress by Stevi Brooks.)

carry-on bag for sportswear should suffice. Make your color selections harmonious. James, you'll notice, has toted a black poly/rayon jacket to wear with the pants from the tan polyester/cotton suit he traveled in. If your destination calls for a dressier look in the evening, coordinate the jacket with a formal wing-collar shirt coupled with a dark bow tie. (If the collar and the tie are a bit too tony for your taste, you can always pack a more conventional dress shirt and tie instead.) By sticking to neutral colors in your sportswear—while mixing in some primary shades—you can put together a variety of looks that should see you nicely through most social situations short of an audience with Queen Elizabeth II. Happy landings!

PHOTOGRAPHS AT HOTEL CABO SAN LUCAS, BAJA CALIFORNIA

26

Although I work really fast, even I was surprised to get this shot in the short amount of time that Clint Eastwood gave me to photograph him. After one roll of film, he said, "You got it, right?" and walked away to do something else.

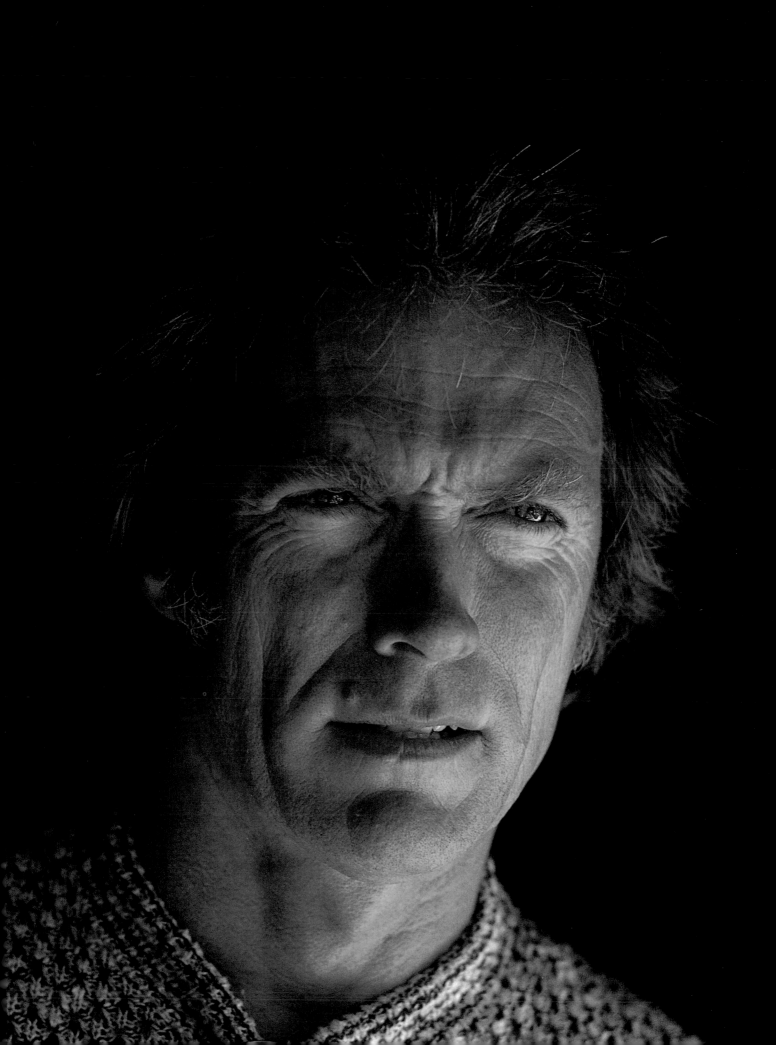

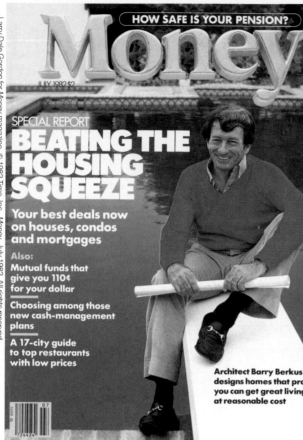

HOW SAFE IS YOUR PENSION?

Money

JULY 1982 $2

SPECIAL REPORT

BEATING THE HOUSING SQUEEZE

Your best deals now on houses, condos and mortgages

Also:

Mutual funds that give you 110¢ for your dollar

Choosing among those new cash-management plans

A 17-city guide to top restaurants with low prices

Architect Barry Berkus designs homes that prove you can get great living at reasonable cost

I did quite a bit of work for Money magazine, but stopped when they departed from the full bleed covers. Now they feature covers that are mostly type with smaller pictures. Photography became less important to the magazine and the pictures inside became tiny and incidental as well. It was time to depart, but they were a good client while the relationship lasted. Meg McVey, the picture editor at the time, has moved on to greener pastures at Newsweek as has Sue Considine, a very special woman and editor whom I originally met when she was working at Fortune magazine. For the most part, the covers were usually taken on location; environmental portraits of real people. Lighting was usually available, but sometimes strobe was used when applicable.

Money

JANUARY 1980 $1.75

WINNER & LOSER OF THE DECADE

The Changing Finances of Dating and Marriage
page 38

Romantic Weekends at a Discount
page 42

Taking the Tax Sting Out of Marriage
page 47

SPECIAL REPORT

LOVE AND MONEY

Entertainer Lynda Carter and her husband-manager, Ron Samuels (page 50)

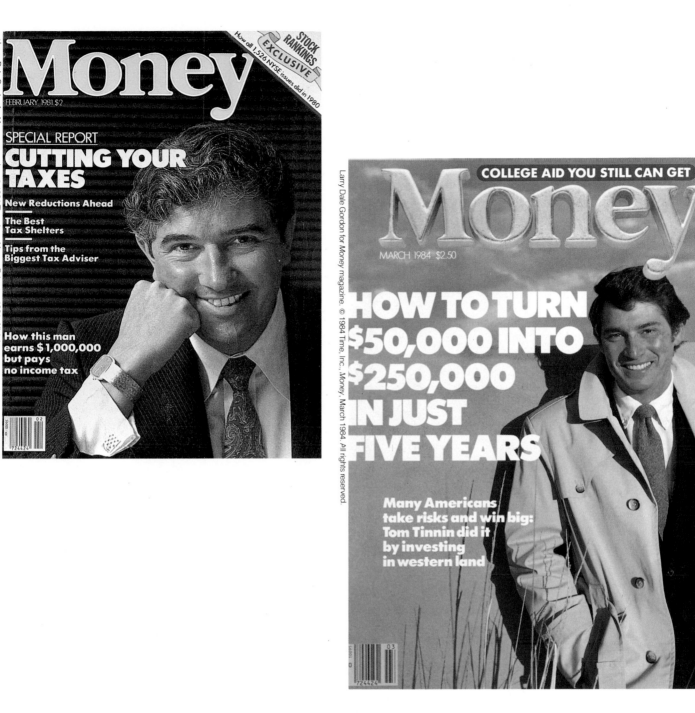

What a client like Money does for you in terms of lessons learned is tenfold. First, there are always deadlines, so you have to get in there and get the picture quickly. Each location is different, each subject is different—in looks and in personality—so you must be adaptable and versatile to get the job done. Editorial, again, is one of the best learning trees. It will teach you many things, not the least of which is how to please a demanding editor like Meg McVey. More importantly, you'll learn how to please yourself with constant experimentation in your chosen profession. Sit on the doorstep of every magazine you've ever wanted to work for, but remember, once you get in, you have to have something to show and an idea to talk about.

LA SICILIA : DUE GENERAZIONI A CONFRONTO

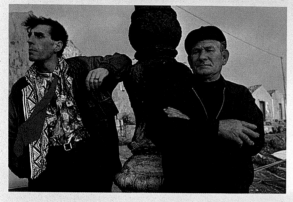

Da una parte, coppole nere, tessuti pesanti, capelli bianchi; dall'altra, jeans, giacche di pelle, camicie sgargianti, ciuffo sulla fronte.
Due diversi modi di essere e di vivere una stessa realtà.

Carla Sozzani, a wonderful woman and an incredible art director who edits about five Italian Vogue magazines (she used these pictures in Vogue Pele), sent me to Sicily with some leather jackets and said take some portraits of the young boys and old men of the village. It was that simple. A few days later my assistant and I were in the small village of Pachino in Southeast Sicily.

We not only found wonderful people with extraordinary faces in the elders of the village, but probably found the best spaghetti alle vongole in the world! All the pasta and seafood were simply the best. I had a hard time not ordering it for breakfast, only being saved by the local breads and cappuccino. It was wonderful. Bless you Carla; I'll go anywhere for you.

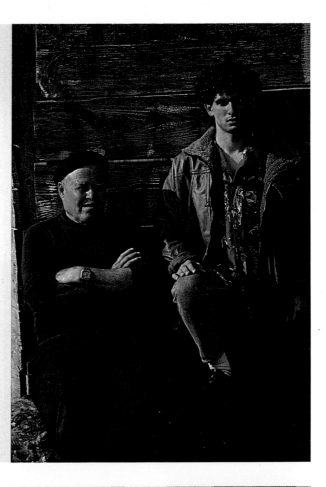

In questa pagina: giubbotto in camoscio grigio chiaro impunturato davanti e ai bordi, con interno e colletto in pelo e allacciatura con bottoni a pressione (Linea T). Sotto, una camicia e una cravatta in tinta (Zeus).

Nella pagina accanto: giubbotto in pelle grigia foderato in lana allacciato con zip, con motivi impunturati sul davanti e sulle maniche e colletto in agnellino (Gruppo Nord). Sotto, una camicia fantasia (Zeus).

70

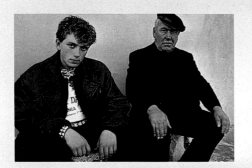

In questa pagina: giubbotto in morbidissima pelle marrone con due tasche laterali più altre due, in alto, chiuse da zip. È foderato in lana e ha il collo in montone rovesciato staccabile (Ruffo).

Nella pagina accanto: un caldo e confortevole blouson in montone rovesciato marrone profilato in pelle con cinturini, sempre in pelle, ai polsi, allacciato con bottoni (Igi & Igi). Sotto, una camicia fantasia (Zeus).

72

This was a series of pictures for the French beauty magazine Votre Beauté, photographed in Palm Springs, California. Never ask your models to do something you wouldn't do yourself. The stream was probably two degrees from being solid water and the girl was courageous indeed. After she braved the cold and the picture was in the can, I stripped and sat in the stream for a minute—to say it was cold is an understatement. I guess I pushed hard for the stream picture because of my love for wet women. I think you have to push for what you think is right without, of course, hurting anyone in the process. A picture at any cost has its limits I think.

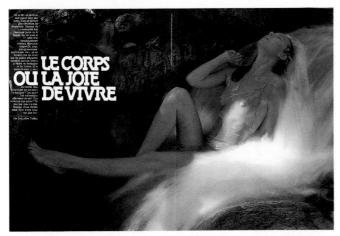

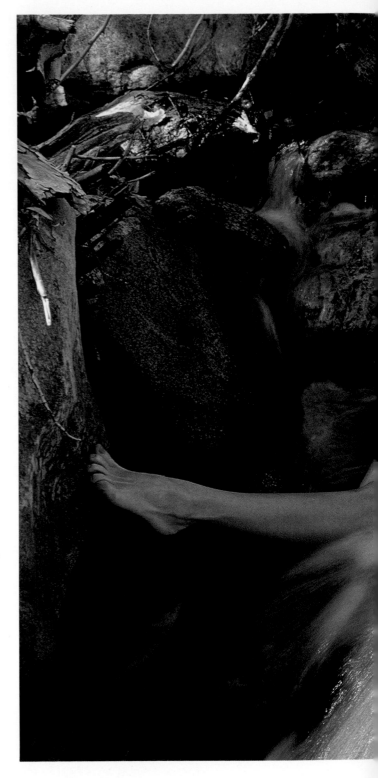

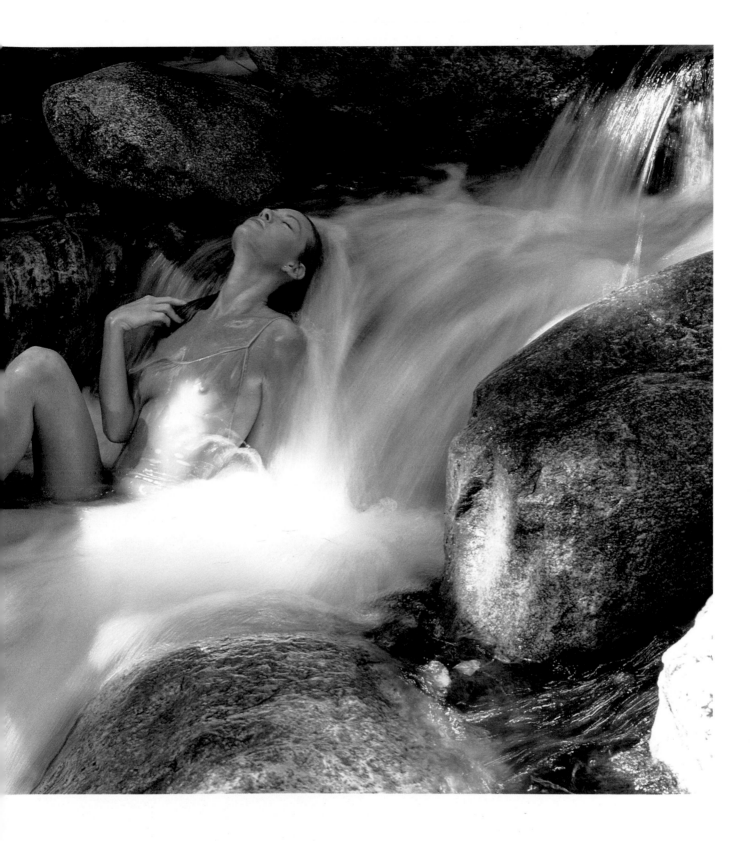

Another set of experimental pictures which are related to my "wet" theme is what I call "The Black Pool" series. The set-up is fairly simple and is based on a mirror; black backs a mirror to make it reflective. It follows that a black pool would give you the same results. You've seen it in the ocean and lakes, even in puddles of rainwater and wet city streets.

For the reflections, I used Day-Glo illustration board on a frame built behind the pool and placed in the sun. The pictures have been published in several magazines, two of which are shown here: German Playboy and American Photographer. This gives you a look at how differently two magazines can lay out and use your pictures.

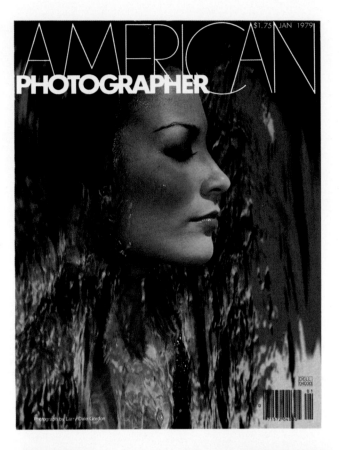

Larry Dale Gordon

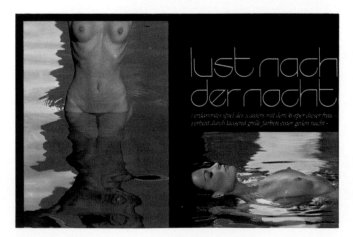

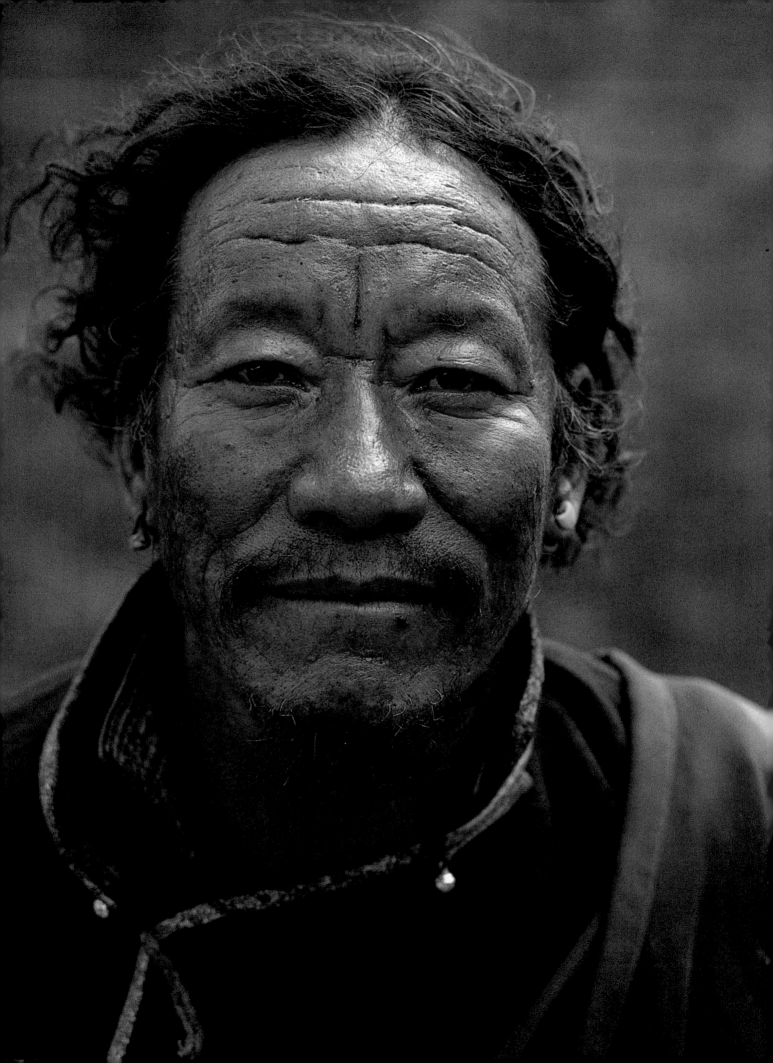

THE PORTRAIT

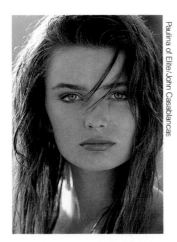

One of the few changes I might have made in my life would be to have photographed more faces. The human face is one of nature's great landscapes, is it not? It is with shape and form. It is the mountains, valleys and lakes of the human personality. It is unique and individual in each and every one of us.

The face is a window, a fortification of the soul, allowing brief glimpses into the person. Again, I think simplicity is paramount when dealing with the human face because it is so powerful an entity in itself. To use gimmicks is to take away from that face, that personality, that soul.

Since I am primarily a location photographer, environmental portraits occur for me more often than studio situations. The portraits on the following pages represent a variety of locations, lighting situations, and subject matter. In most situations, environmental portraits dictate that you move the subject to the light if you have time and the subject is agreeable, or speaks your language. If moving is not possible, you take the picture on the spot with the probably limited equipment you are carrying, most likely only your camera. Unless it's an assigned and planned portrait, you have to be innovative on location. Look hard at the things you have to work with and try to get them working for you to make the picture. Most nonprofessional subjects do not understand a photographer taking thirty-six pictures at a clip. They are expecting a "snapshot." Go beyond one or two frames and they then wonder what you're up to. It's best to work as quickly as is possible, within your own needs, before the subject becomes uncomfortable and wants to move on.

Design elements are certainly there and can be considered, either in the juxtaposition of the subject and background or the subject's position in the frame. And, as with any landscape, I look for texture; or, in the case of "Beauty," the lack of same, although texture might be introduced with a model's hair, or the clothes or background.

I'm sure most photographers have their own secrets for photographing people. As for myself, I must admit I can't think of a single secret used in getting a great portrait. I do know I like to let things happen in a natural way and that takes time. I usually don't expect anything in the first roll or two of film; I look at these as "warm-ups." I do remember one session with Clint Eastwood; I had just about finished one roll of film (and I work fast) and Clint said, "You've got it, right?" and went off to do something else he was working on. Fortunately, I did have it. One can hardly go wrong with that face.

The above situation is an example of what it's like to work with most celebrities; you usually get very little time with them and they have little patience with the still camera. In fact, many are slightly frightened of it. The secret in working with celebrities is to work fast and know what you're doing; look unsure of yourself and you're in deep trouble.

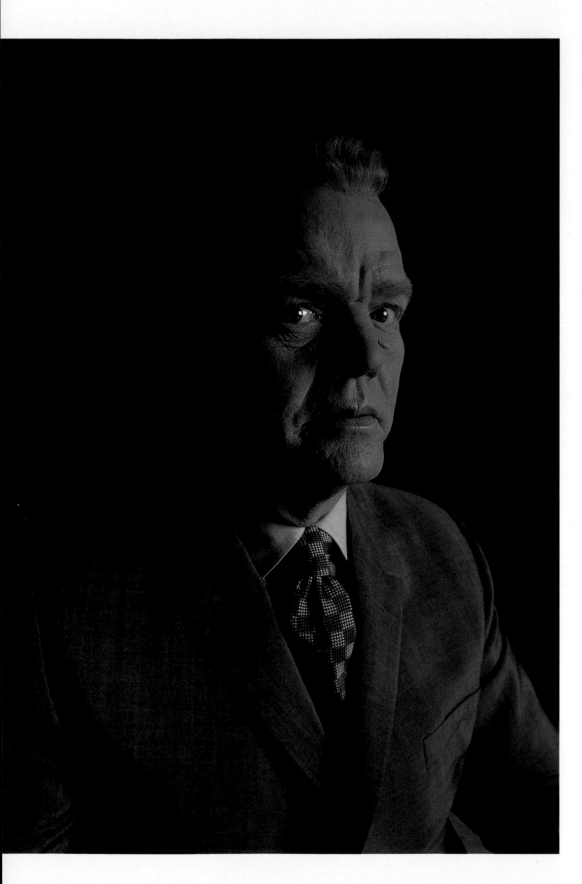

These two very strong characters were photographed for Esquire some time ago when I lived in New York; both pictures were taken in the men's respective offices. There is a great story about the Paul Harvey portrait on the left: the magazine went all the way to color plates before they realized they hadn't retouched his toupee, which apparently had been part of the bargain. The original was rushed to Chicago for retouching, but they ran out of time before the magazine went to press. It was converted to black and white, but still not retouched. I understand there was quite a commotion over the incident. He was wearing too much make-up as he was "on the air," but I still like the portrait very much.

General "Slam" Marshall was a true war hero and great character. I preferred an environmental portrait, but the magazine went with a close-up. It is never possible to second-guess picture selection; get used to it. Both of these portraits were made with strobes through translucent umbrellas on Kodachrome II. Remember that wonderful film? I wish it were still here now.

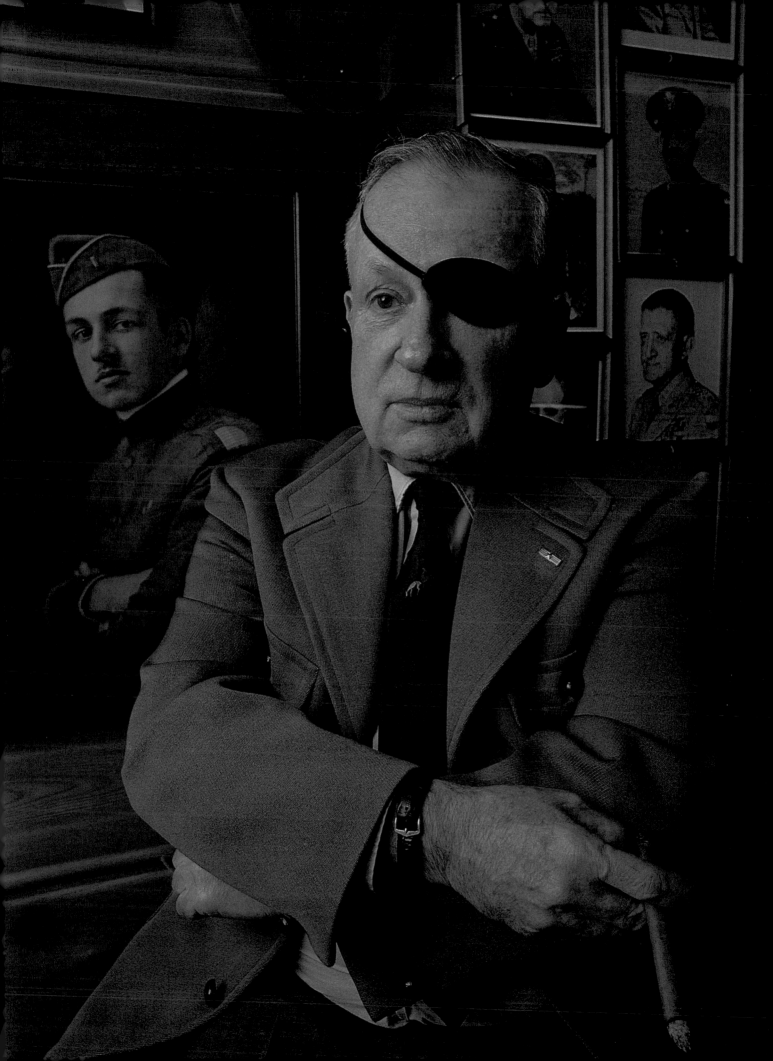

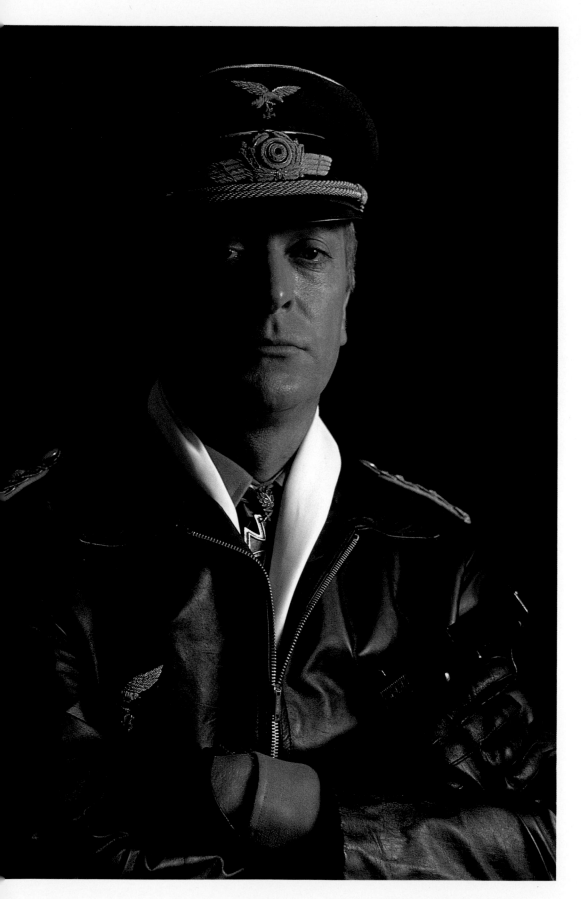

Michael Caine, the consummate actor and original cockney, is a workaholic who does as many films a year as he can. Keeping busy is his elixir for life. This portrait was done while he worked on The Eagle Has Landed which was filmed in his own English countryside. We worked in the prop tent with a quick, makeshift black background and a small portable strobe; it took only six minutes to get this picture.

This strong portrait of sculptor Cezar was taken on location at the Regent Hotel for the Hong Kong magazine The Peak, during a show of his work in conjunction with Cartier. We couldn't, of course, move his sculpture, so we built the dark set around him and lit the scene with strobes. I probably used slightly wide-angle to drama- tize the cans a bit. It's one of my favorite pictures, at least up to this point. That changes constantly, which I suppose is fortunate; it keeps you trying to better yourself. I'd hate to be in love with one picture; it's like being in the rut I've been talking about in this book. To stay out of it, you have to constantly try to better your last job, or assignment, or picture.

OVERLEAF

An image out of my past. I grew up with Roy Rogers; he could ride the smoothest and shoot the straightest of all the cowboys of those days. Being able to photograph him and Dale Evans was sheer pleasure; they are truly wonderful peo- ple. This was originally taken for Town & Country and later published in a book, Cowboy, the Enduring Myth of the Wild West, by Russell Martin. To me, Roy was the ultimate cowboy.

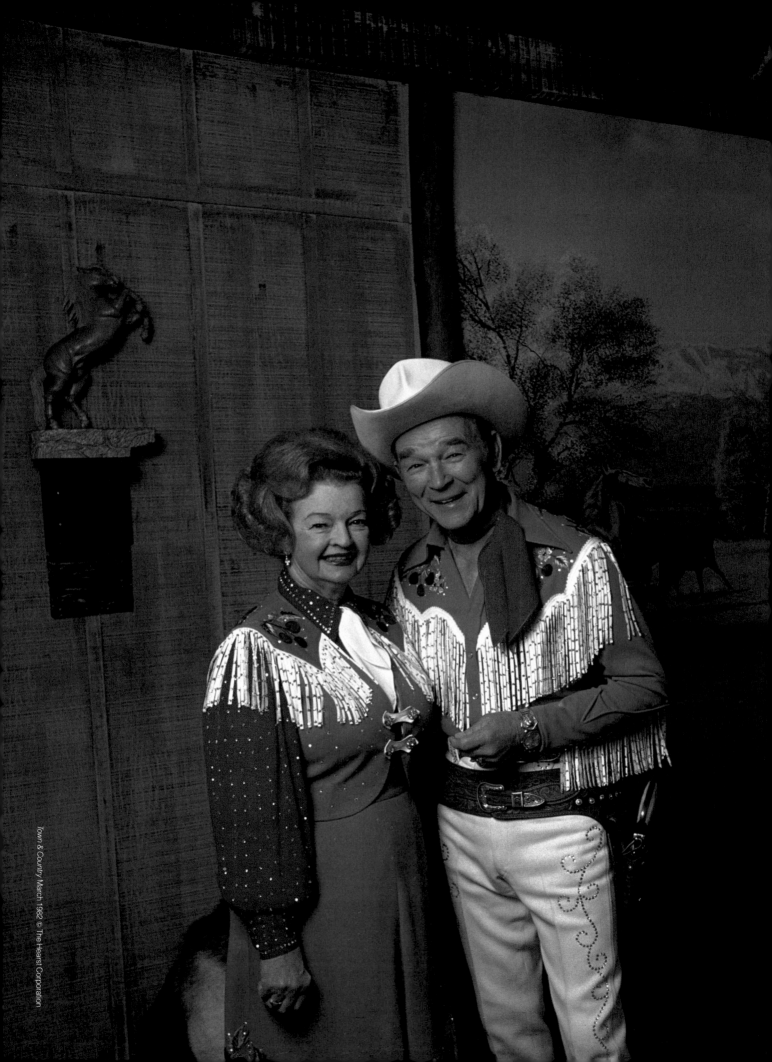

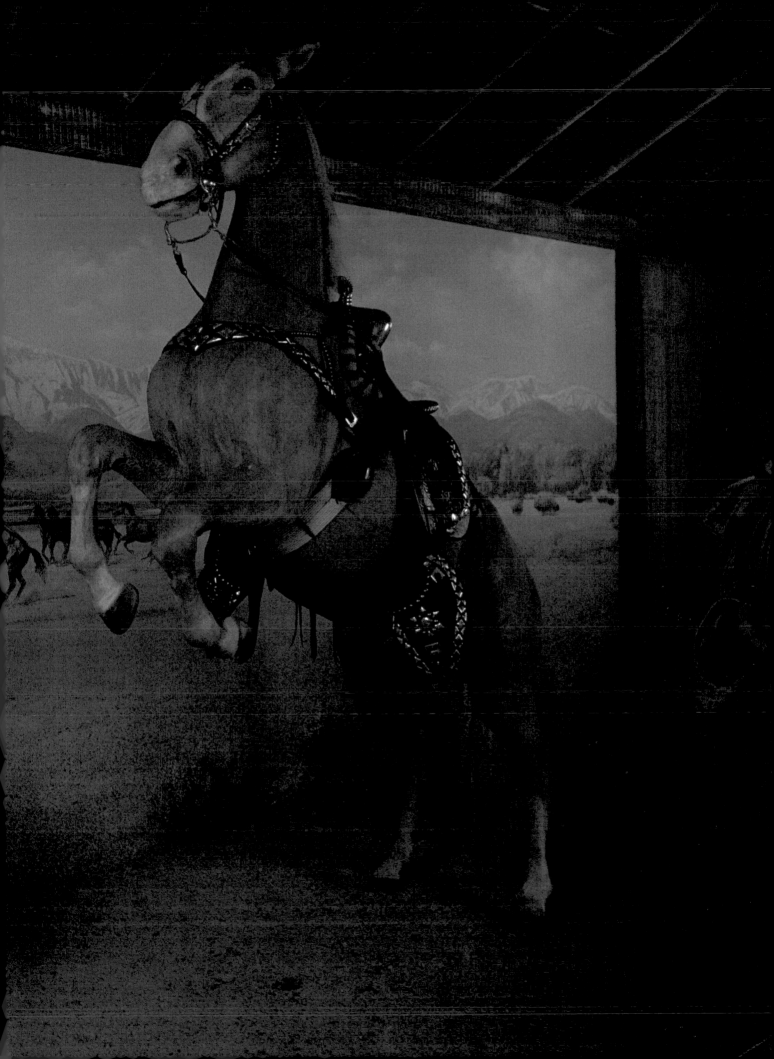

Working with celebrities has its own set of problems, all stirred up and fraught with egos, but Robert Wagner and Natalie Wood were two of my favorite people and sheer pleasure to work with. A lady and gentleman of great style, they both made my job an easy one. Plus we all lost weight at The Golden Door Spa.

The three pictures shown include a variety of lighting problems and solutions. The cover was a studio set-up, done in the Wagner home to meet their rigorous schedule. The cover was set up and done in less than an hour and a half. The light is from strobe, through a translucent umbrella, and a single hair light, diffused through a snoot.

The picture of a reclining Natalie was done on her terrace at The Golden Door. Sunlight was diffused through a translucent shower curtain. We wet the stones because they looked better that way. The portrait of "RJ" is one of my favorite pictures; it's casual and I think we caught the "roguishness" of the man—he is a very debonair and continental gentleman. This was shot in the open shade of the massage area, with a semi-long lens and nothing else added.

Town & Country January 1979 © The Hearst Corporation

TOWN & COUNTRY

JANUARY 1979/$2.00

ESTABLISHED 1846

HOW TO PROLONG YOUR LIFE
A Step by Step Program Developed by Santa Barbara's Famous Longevity Institute

EXPERTS PREDICT
There's Good News — And Bad — About Education, Inflation & Living Standards

SEXY, SAUCY ACAPULCO
New Darling of the International Set

0 01
754754

Robert Wagner & Natalie Wood: Health & Happiness After 40

With celebrities, it's important to be quick, as they are not good at waiting around, especially if they feel they are not with professionals. This is strange considering they do so much waiting on sets when making films. You must have your shots well-planned in advance, so you are ready when you call them to the set. Use stand-ins and have your lighting set; it's hard to ask a "star" to sit in while you adjust your lighting for twenty minutes. They will not stand for it, nor should they have to.

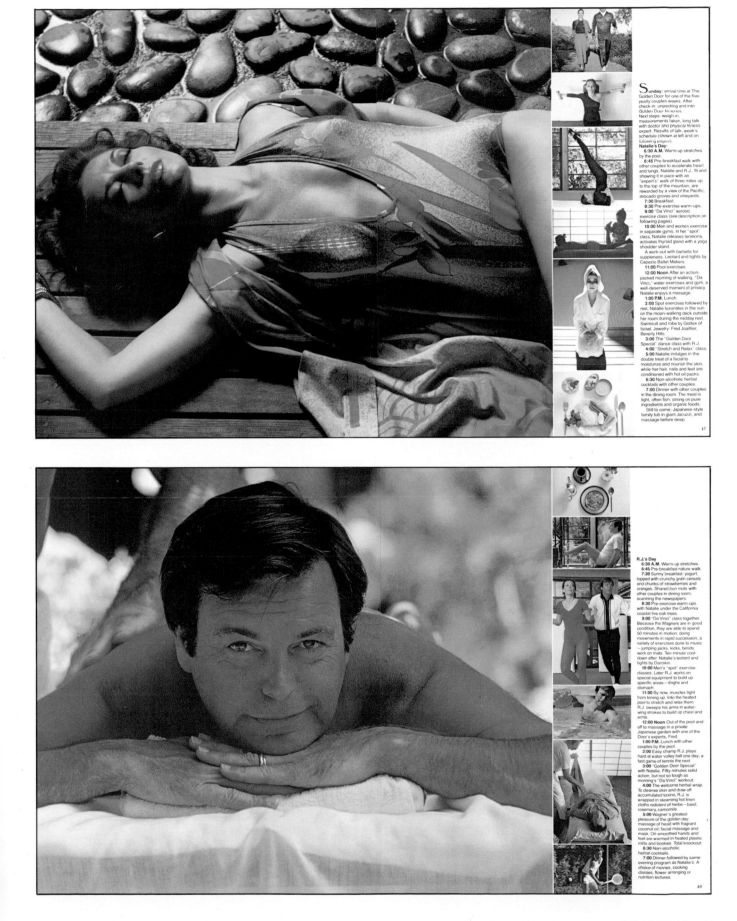

Sunday: arrival time at The Golden Door for one of the five-yearly couples weeks. After check-in: unpacking and into Golden Door kimonos. Next steps: weigh-in, measurements taken, long talk with doctor and physical fitness expert. Results of talk: week's schedule (shown at left and on following pages).

Natalie's Day:
6:30 A.M. Warm-up stretches by the pool.
6:45 Pre-breakfast walk with other couples to accelerate heart and lungs. Natalie and R.J., fit and showing it pace with an "expert's" walk of three miles up to the top of the mountain, are rewarded by a view of the Pacific, avocado groves and vineyards.
7:30 Breakfast.
8:30 Pre-exercise warm-ups.
9:00 "Da Vinci" aerobic exercise class (see description on following pages).
10:00 Men and women exercise in separate gyms. In her "spot" class, Natalie releases tensions, activates thyroid gland with a yoga shoulder stand. A work-out with barbells for suppleness. Leotard and tights by Capezio Ballet Makers.
11:00 Pool exercises.
12:00 Noon After an action-packed morning of walking, "Da Vinci," water exercises and gym, a well-deserved moment of privacy. Natalie enjoys a massage.
1:00 P.M. Lunch.
2:00 Spot exercises followed by rest. Natalie luxuriates in the sun on the moon-walking deck outside her room during the midday rest. Swimsuit and robe by Gottex of Israel. Jewelry: Fred Joaillier, Beverly Hills.
3:00 The "Golden Door Special" dance class with R.J.
4:00 "Stretch and Relax" class.
5:00 Natalie indulges in the double treat of a facial to moisturize and nourish the skin, while her hair, nails and feet are conditioned with hot oil packs.
6:30 Non-alcoholic herbal cocktails with other couples in the dining room. The meal is light, often fish; strong on pure ingredients and organic foods.
7:00 Dinner with other couples in the dining room.
Still to come: Japanese-style family tub in giant Jacuzzi, and massage before sleep.

47

R.J.'s Day
6:30 A.M. Warm-up stretches.
6:45 Pre-breakfast nature walk.
7:30 Sunny breakfast: yogurt, topped with crunchy grain cereals and chunks of strawberries and oranges. Shared bon mots with other couples in dining room, scanning the newspapers.
8:30 Pre-exercise warm-ups with Natalie under the California coastal live oak trees.
9:00 "Da Vinci" class together. Because the Wagners are in good condition, they are able to spend 50 minutes in motion, doing movements in rapid succession; a variety of exercises done to music — jumping jacks, kicks, bends, work on mats. Ten-minute cool-down after. Natalie's leotard and tights by Danskin.
10:00 Men's "spot" exercise classes. Later R.J. works on special equipment to build up specific areas — thighs and stomach.
11:00 By now, muscles tight from toning up. Into the heated pool to stretch and relax them. R.J. sweeps his arms in water-wing strokes to build up chest and arms.
12:00 Noon Out of the pool and off to massage in a private Japanese garden with one of the Door's experts, Fred.
1:00 P.M. Lunch with other couples by the pool.
2:00 Easy champ R.J. plays hard at water volley ball one day; a fast game of tennis the next.
3:00 "Golden Door Special" with Natalie. Fifty minutes solid action, but not so tough as morning's "Da Vinci" workout.
4:00 The welcome herbal wrap. To cleanse skin and draw off accumulated toxins, R.J. is wrapped in steaming hot linen cloths redolent of herbs — basil, rosemary, camomile.
5:00 Wagner's greatest pleasure of the golden day: massage of head with fragrant coconut oil; facial massage and mask. Oil-smoothed hands and feet are warmed in heated plastic mitts and booties. Total knockout.
6:30 Non-alcoholic herbal cocktails.
7:00 Dinner followed by same evening program as Natalie's. A choice of movies, cooking classes, flower arranging or nutrition lectures.

49

John Travolta, in Gilley's, on the mechanical bull featured in the film Urban Cowboy. Also shown is the People magazine cover with the shot they chose and changed. It's as I said, there is no accounting for picture selection. Travolta was very shy, but easy to work with and I enjoyed meeting him. He's a very complex man, made more so by the business he's in.

Celebrities and the photographing thereof presents its own unique set of demands. These are not always problems, but they are definitely demands. It's rather like walking on eggs, while handling the camera with kid gloves. This all has to do with the supreme egos you will be dealing with; not only those of the stars themselves, but of their omnipresent entourage: the agents, the managers, the secretaries, the studio heads, the drivers, special caterers, hair and make-up people—the list goes on and on. They invade your studio like the Mongolian horde of Genghis Khan. You must keep your wits about you and handle it all with aplomb and a professional air, or everything will fall apart. Keep in mind they are people, just like you and I, but the key is, they think they are very special people and we, the public and our beloved press, have made them what they are today. So you have to deal with it. Also, almost every star I've dealt with is petrified of the presence of the still camera; if not petrified, then certainly very nervous. It all stems from the idea of an image locked in time forever. The movie camera image moves and that covers a multitude of sins and flaws. The still photograph preserves them and those flaws for all the world to see; it's an uncomfortable feeling for someone who makes their living on how they look. There are also many publications that we all know that are indiscriminant in their picture usage.

Most of the time, photographing celebrities is a great experience if you can set them at ease. But sometimes, you never break through their barriers and that's a tough day indeed. If they feel you are a professional and you move through the day knowing what you are doing, fine. If you give them a feeling of insecurity and don't have your concept well planned, with minimum delays, you will be in trouble and will feel like your whole studio has crashed through seven stories of raw eggs.

I don't seek out celebrities to photograph as I'm not comfortable riding the success of others, but I have photographed a few.

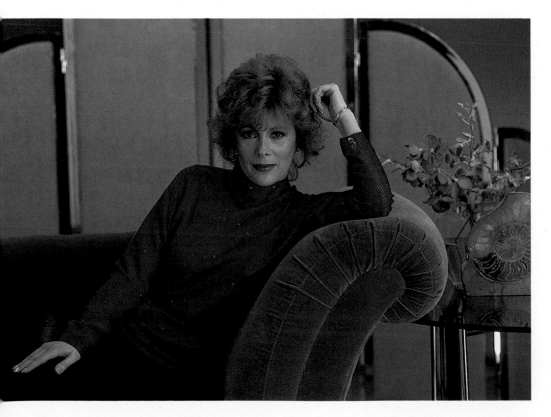

Jill St. John, a beautiful and talented woman. She was fun and easy to work with, although I don't think she liked the picture very much. We had a great set put together, which was immediately cropped out by the art director, Cindy Barnett, or maybe her boss. Jill knew about still photography and about lighting and she let me know what was best for her and her best side.

The MASH portrait was probably one of my most enjoyable assignments. What a lovely group of people. It was the day before the final day of filming of the series as a network show. Loretta Swit's eyes were already red-rimmed from crying; it was an emotional day, but if you look at the picture, you see these were happy people who were doing something they loved. There were extremely kind to me, giving me enough time between takes to do two set-ups for the Newsweek cover. Again, I liked the one they didn't use. The backdrop was tent canvas, the other was the interior of "The Swamp." Lighting was by strobe and umbrellas. Everything was set-up and exposed in two sessions totaling about an hour.

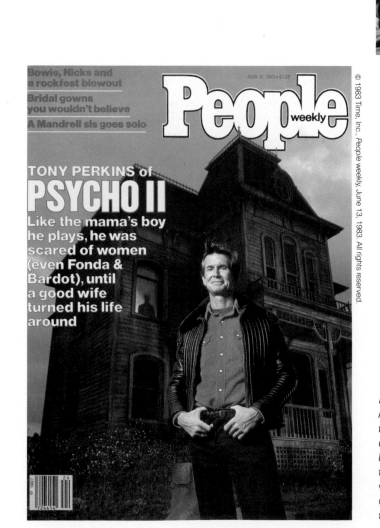

Norman Bates and the Bates Motel. The house still exists on the lot of Universal Studios. We used it for the picture with Tony Perkins and put his "mother" in the lighted window, lighting him with portable strobes and umbrellas. He is an extremely talented and interesting man.

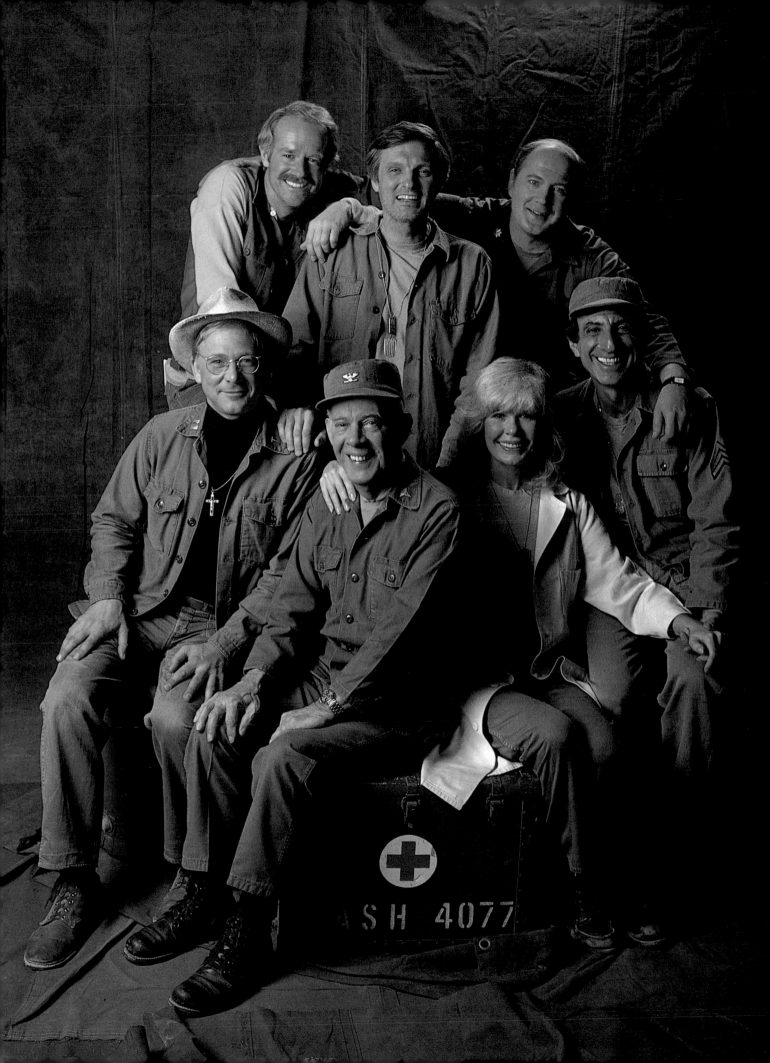

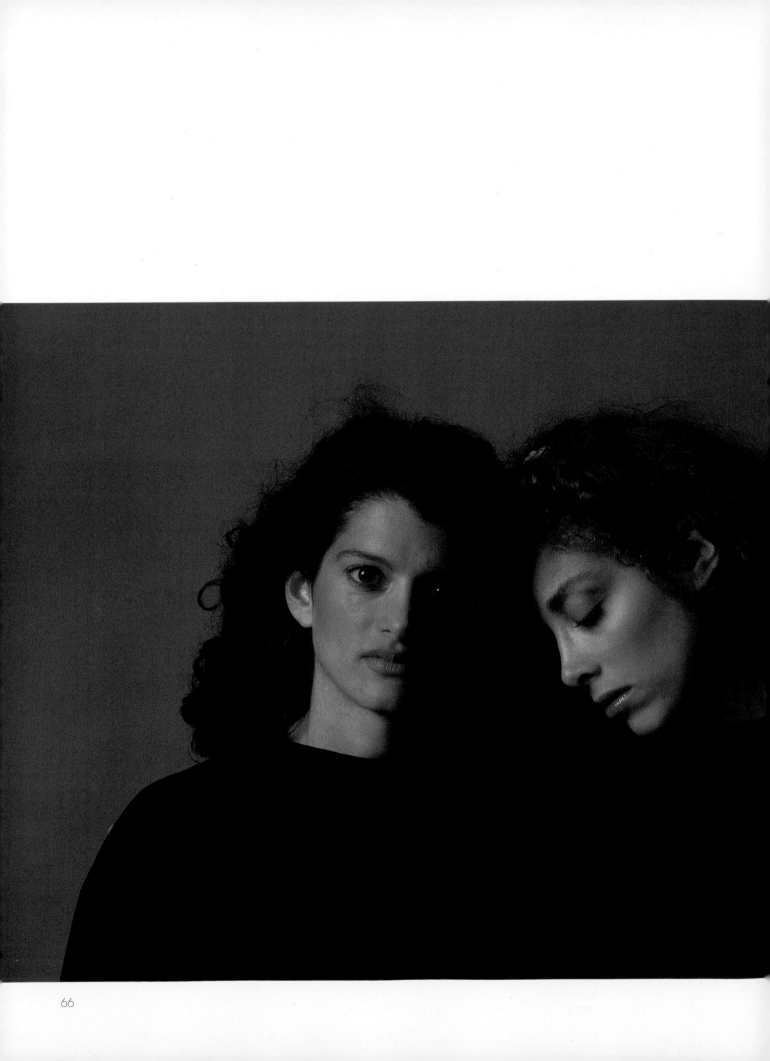

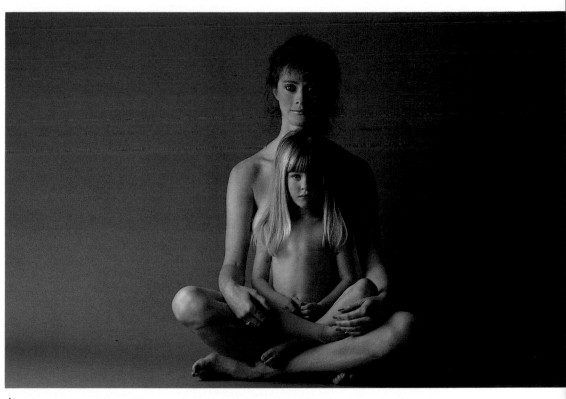

I have, from time to time, made portraits in controlled studio and studio-like situations. The examples shown here were taken both in the studio and with strobe on location. Both pictures of the sisters and the mother with her little girl were photographed using a 4x4-foot bank light and Kodachrome.

I met the two sisters in a sushi bar and was so fascinated with their look that I asked if I could photograph them together. I became good friends with Anita of the wonderfully big eyes; she designs Triathalon and biking clothes out of New York (Alita). Her sister, with all that lovely hair, is an actress.

OVERLEAF

This little boy was photo-graphed in a small, outdoor cafe on the Colombian island of San Andreas. A stool brought him up to the height of the paintings. What an actor he was.

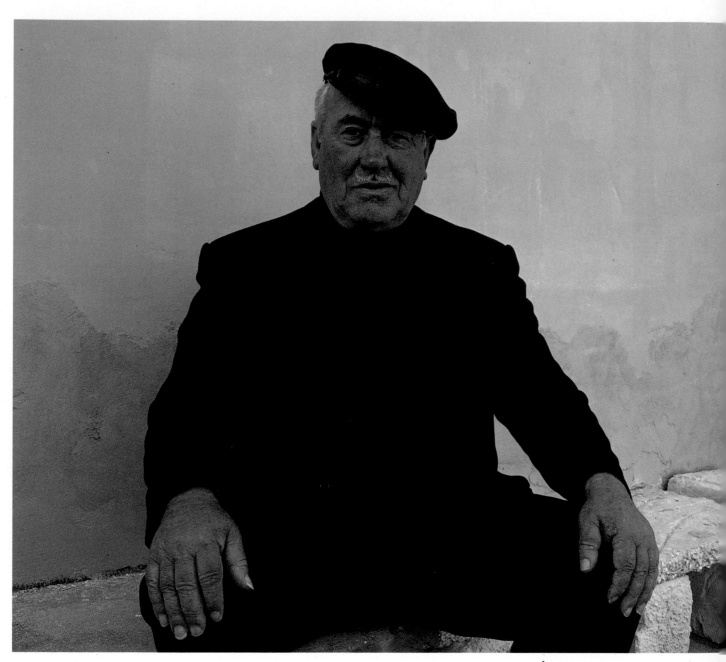

A Sicilian fisherman from Pochino with a grand manner and bearing. He should have been a king; he was a king. The portrait was done while on assignment for Vogue Pele, out of Milan.

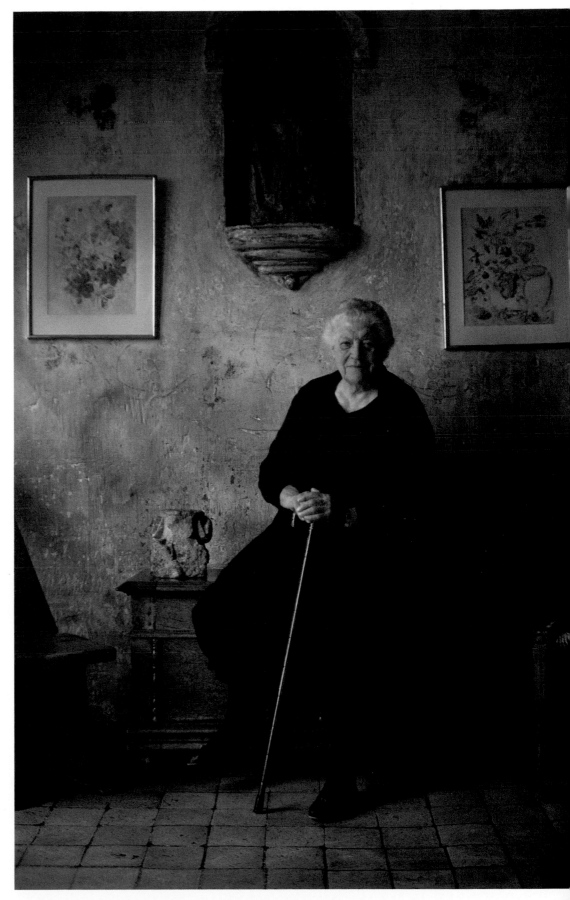

*M*adame Roux, whose family has owned the world renowned Colombe d'Or in St. Paul de Vence in the South of France for over a century. One of the truly great hotels for a romantic interlude, or anything else for that matter. She was stoic for one roll.

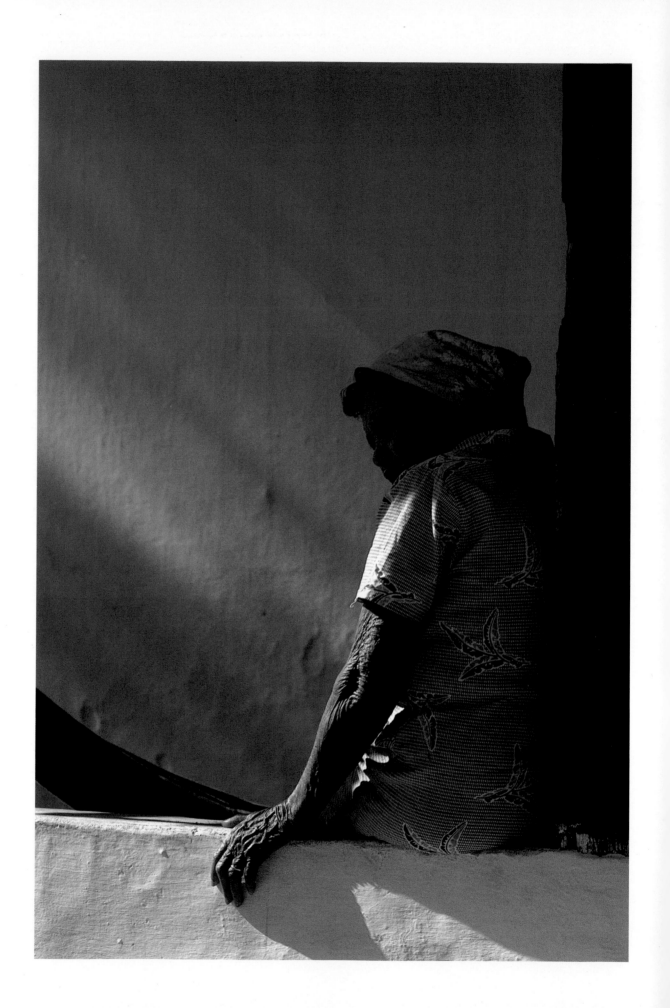

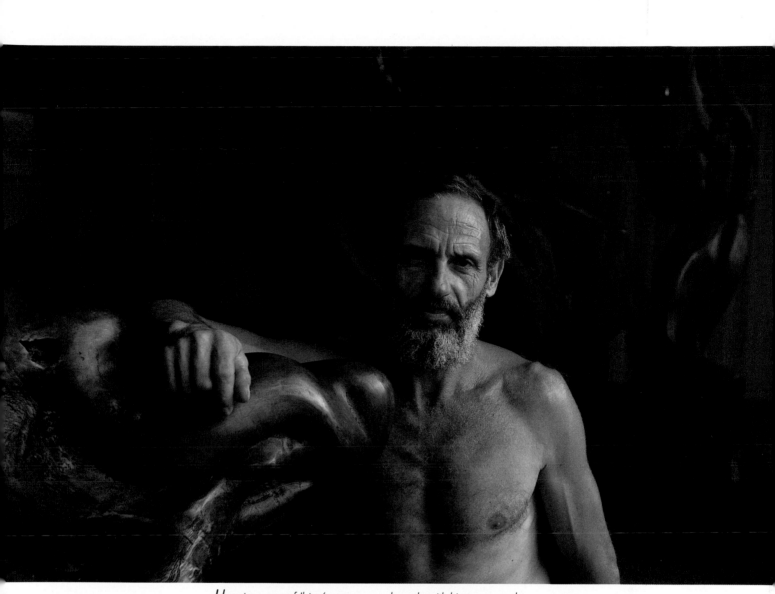

Hormigo, one of Ibiza's premier sculptors. Between the time spent pushing around the massive olive trees that are his material, he lifts weights, rides his bike into town for Spanish brandy with his peers, and loves the ladies. He loves life too, and is now putting a show together that will take about five years to produce. What patience.

A portrait of a probably long and hard life, taken at a fisherman's cottage in Buzios, Brazil.

OVERLEAF

I photographed these young Buddhist monks on the steps of a monastery in the Paro Valley in the tiny mountain kingdom of Bhutan. The texture of the monastery, the people, and the mountains was extraordinary.

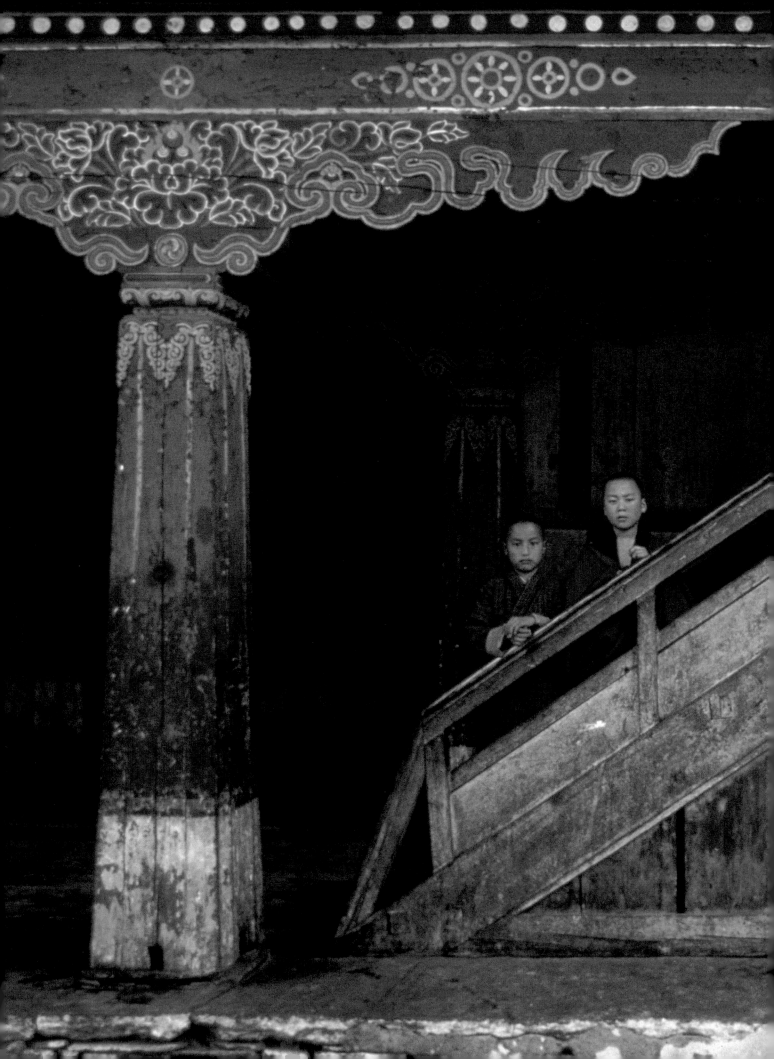

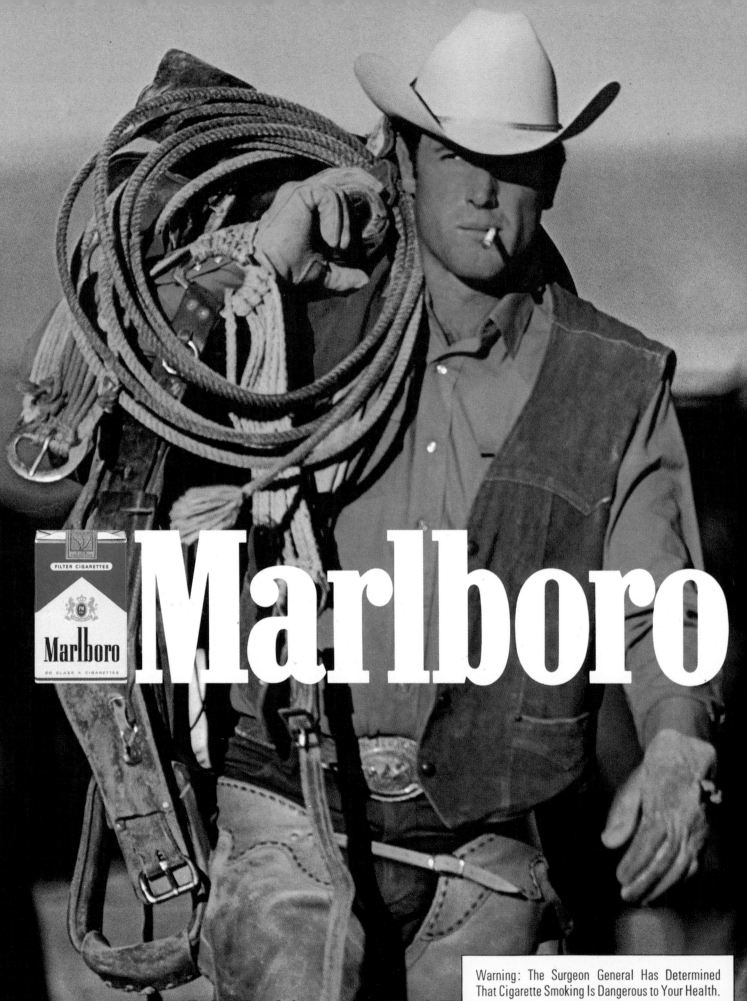

Marlboro

FILTER CIGARETTES

Marlboro

20 CLASS A CIGARETTES

17 mg "tar," 1.0 mg nicotine av. per cigarette, FTC Report Aug.'77

ADVERTISING ILLUSTRATION

GET INTO
THE SLIM OF IT WITH
GREAT LYMON TASTE.

ONLY DIET SPRITE.

If it's "big bucks" you're after in this business, here is where to hang your hat. But one should remember that, as in most of life's endeavors, something never comes for nothing; you pay a price. It is a very tough road to the top in advertising photography and the competition is the best there is. All the "old timers" up on top just don't want to leave the mountain. It's a rarefied atmosphere and, with very few exceptions, it's been a long hard climb with count-less dues paid and remembered. Usually the only way a top photographer comes down is in a long hard fall.

Advertising illustration is the selling of a product, photograph-ing that product alone or with people in a number of ways. It could be in the studio or on location, depending on the client's needs and the agency's plan in their approach to selling that product. It's a complicated and expensive business. Much is at stake and there are fewer jobs than photographers seeking them. It's a very competitive area of photography, but exciting because of that competition. You're sharing the stage with the very best and it's no place for amateurs.

The direction you choose, whether it be in the studio with the still life, or on location as an illustrator, should be chosen early in your career, as it will take your every effort and a good deal of time to make it all work. Consider too that in this area of photography you will be dealing with countless types of people and it's best to be good at it. If you don't care for humankind and the myriad personalities who work in advertising, it might be best to choose work in another profession.

I've done a good deal of studio work over the years, but have always preferred to work with people and/or the product outside; to see that sun rise and set. It's a much more spiritual way of life for me than electronic flash. Again, it's a matter of choice; I've probably seen more sunrises and sunsets than almost anyone in the business. It's my own personal religion.

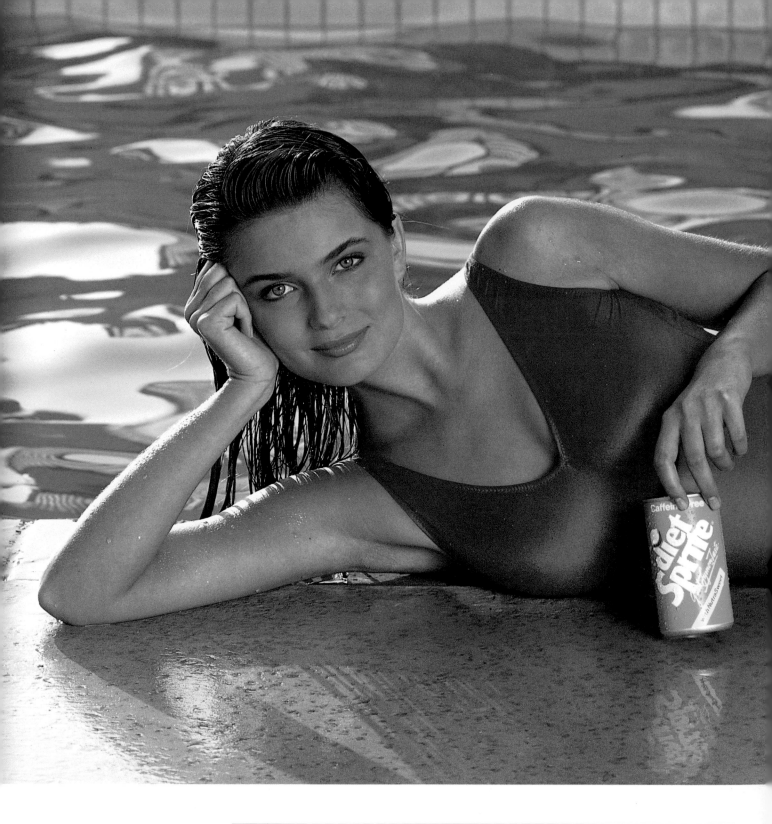

Beauty, like all subjects, needs light. It is a special kind of light, usually a broad and flat source coming in from somewhere near the camera. This type of light and direction will cover a multitude of sins and flaws in the human face. The beauty face is as close to a perfect face as you can make it, but like most landscapes, it has shape: valleys and plains, mountains and sometimes some pretty rocky surfaces in its normality. These things have to be erased and cajoled into perfection. The right beauty face is put together in a very special way and actually you will have little trouble recording it that way.

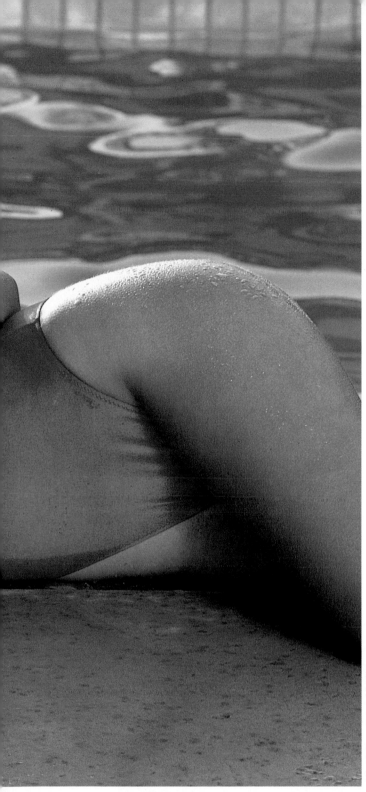

The Sprite ad shown on page 77, through the parent company Coca Cola, was done in conjunction with a television production. This is never an optimum situation, as both "directors" seem to get in each other's way, or so they think. The great joy on this assignment was working with Maria Phillips from Coca Cola in Atlanta and art director Anthony Paneth from Marschalk. Both were a delight to work with and photographing Paulina was an added pleasure indeed. She is not only a beautiful woman, but a consummate professional and a very nice person as well. A hard combination to find in this business.

Even though the pool was outside, it was primarily a studio lighting set-up. I preferred a more natural situation, so I took this picture, which was used on a billboard, while passing some idle time. I think it would have sold a lot of Sprite.

You cannot always have a Paulina, but the model is a big percentage of your picture; they can make or break you. It's not a place to cut corners, as they do so much of in today's advertising. You need a pro and you need one that has that elusive quality we call "photogenic." It doesn't matter what they look

like in person; they have to have it on the two-dimensional surface of a photograph. It's not even the same for motion picture film or tape, where you have movement to carry the scene. In a still photograph you are locked in forever—and that's a long time to look at a mistake.

There is a little side story about Maria and her sense of humor, or perhaps lack thereof, in this case. On location, my assistants have a pre-planned list for cooler refreshments, a list I've gone over and think right for the clients and locations involved. It might include champagne and caviar, or a certain Mexican beer, a special bottled water, and always lots of soft drinks and juices. Well, I happened to include cans of 7-UP, the arch rival to Coke. Maria came up to me and, in all seriousness, asked me to get rid of the "other product." I thought she was kidding, but I'll tell you, she was dead serious and the 7-UP went by the wayside; a lesson learned the hard way about this sometimes crazy business. Maria did keep her sense of humor about the incident and we've stayed friends, but I suppose it could have gone a different way depending on the personalities.

Paulina of Elite/John Casablancas

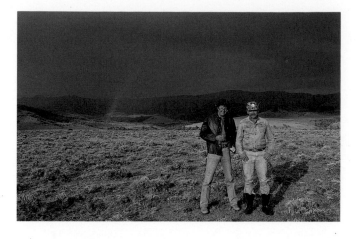

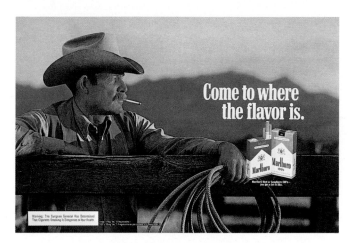

Come to where the flavor is.

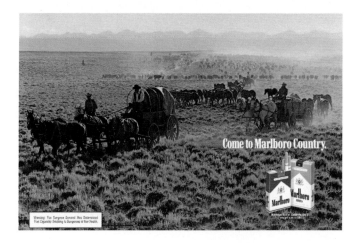

Come to Marlboro Country.

During my advertising career so far, I've been fortunate to work on one of the best accounts in the industry. Marlboro (Philip Morris is the parent company) is still one of the few clients to use photography for itself, as a catalyst for the ads rather than trying to force the picture into a preconceived layout. It's a rare phenomenon in advertising today, where clients along with the business and money people have taken such control of the creative. Marlboro allows the agency, Leo Burnett out of Chicago, to do what it does best: create advertising. Burnett allows its art directors to do what they do best: create and lay out ads. The art directors allow the photographers to do what they do best, which is to make photographs. It is one of the best client-agency-artist relationships I've come across in twenty years of work in and around advertising.

If I've lead you to believe it was a great account to work on, I've succeeded. It was and I assume it still is. The ads you see are some of my favorites out of almost a hundred ads produced. The two people in the portrait are me and Don Johnston, the art director at that time, who is now responsible for Merit. Not pictured as he was not on this location is Ken Krom, the creative director on Marlboro for many years and the man responsible for much of the campaign's early and continued success. It was a great team and we made some great ads along the way.

Going out on a Marlboro assignment was the epitome of location advertising in that one had to apply all the elements to make it work: location scouting, travel logistics, both editorial

and set-up situations, action, portraits, scenics, and varied lighting demands using the best source possible—natural light. There is a saying at Leo Burnett regarding the cowboys: "You can make a model out of a cowboy, but you can never make a cowboy out of a model!" And it's very true. The cowboys were cowboys, and they were a symphony to watch and work with. All the situations you see photographed are out in the authentic American West. We set up cameras and let it happen. There were many times when a scene unfolded before me where I would get rather choked up with the beauty and power; after all, we were watching a piece of American history. The cowboys used to give me a real "leg pulling" over those moments, such as the one on pages 82 and 83. It was worth it.

There would be a central theme each time we went out, such as action, or billboards (simple graphic situations), or portraits. When the photography was completed, all the film was returned to Leo Burnett, where the ads were "built" around our efforts of the week or month. The ads were then presented to the client in New York. If you did your job right, they "bought" the ads. If they didn't, you still had the day rate you went out for. It was the best: hard and challenging work, gratifying and well paying if you made great pictures. If you ever come across an account like this, grab it and run. Forget the money (to a point), just do the work, make great pictures. In the end you will be glad you did. Although you do make good money on an account like Marlboro, it's the byproduct of the experience.

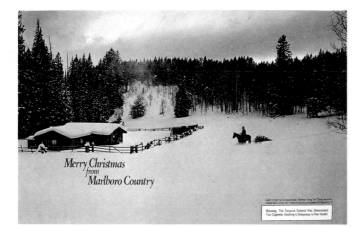

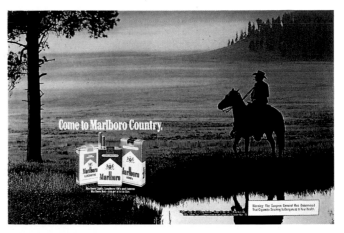

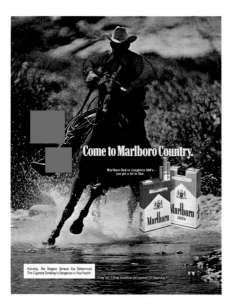

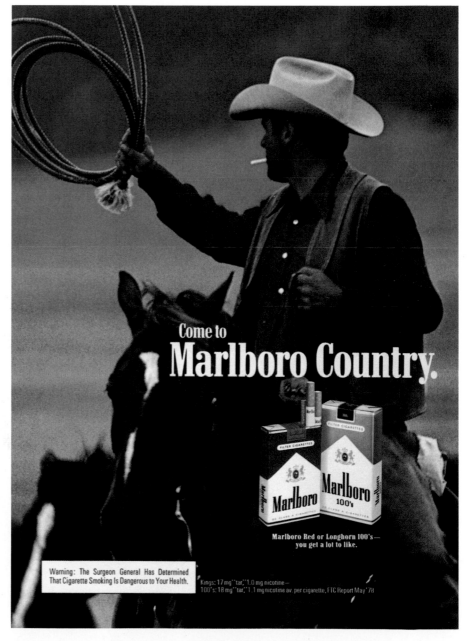

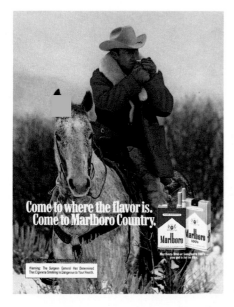

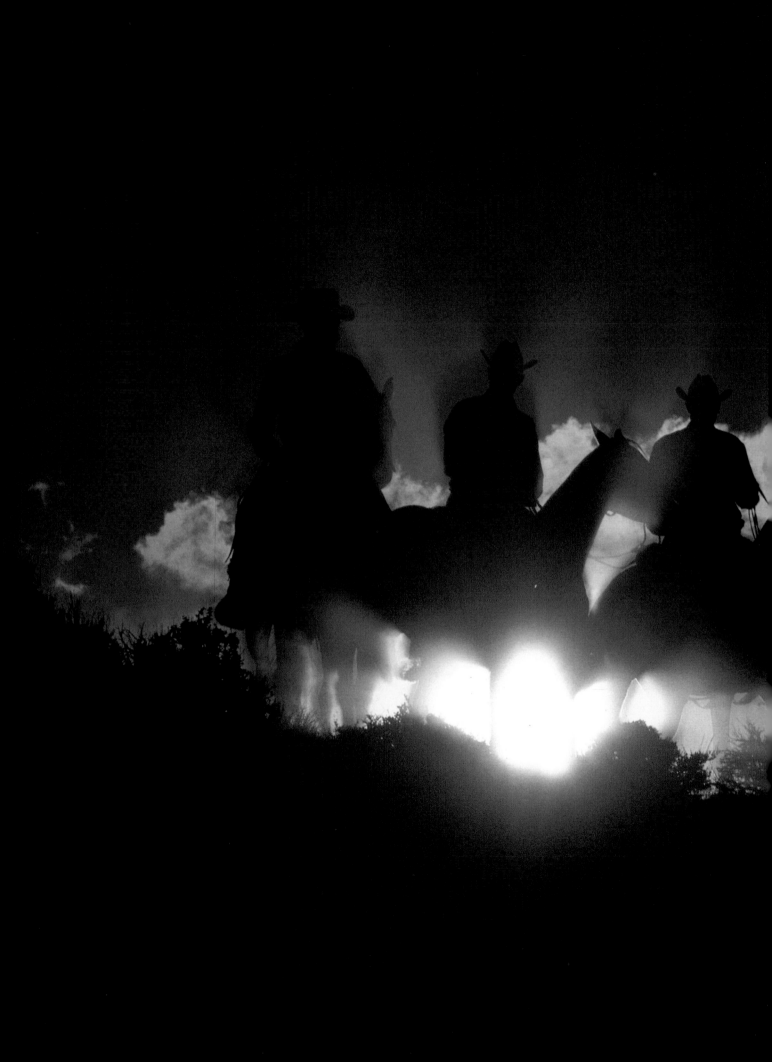

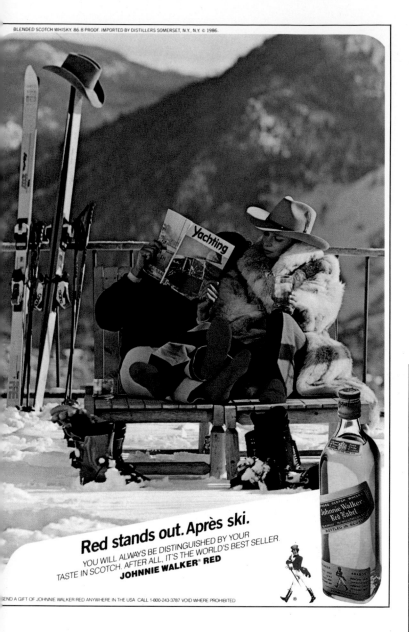

Red stands out. Après ski.

YOU WILL ALWAYS BE DISTINGUISHED BY YOUR
TASTE IN SCOTCH. AFTER ALL, IT'S THE WORLD'S BEST SELLER.
JOHNNIE WALKER® RED

SEND A GIFT OF JOHNNIE WALKER RED ANYWHERE IN THE USA. CALL 1-800-243-3787. VOID WHERE PROHIBITED.

*P*erhaps more than in any other business, there are great pockets of humor in advertising and if you don't keep a sense of it, you're in deep trouble. Here is a great example of that humor and a little hard-nosed reality. Jonas Gold, the art director on the Johnny Walker Red campaign done by Smith Greenland Inc., a New York agency, does have a sense of humor; he sent along his work print, a dye transfer, with his retouching notes scribbled en masse, with the comment "Perfect picture Larry!" Amusing? Yes, but there is a lesson to be learned here; you have to keep your sense of humor and your perspective—and you have to live with the retouchers.

It's not that I resent retouchers. I resent how they are used. If the advertisers want a painting, why not take an illustrator out on location? This picture was a relatively simple outdoor scene using natural light and two 4x8 reflectors—that's it. It would have been nice to see how the un-retouched picture would have reproduced, but that's a situation we probably will never see. The point is, you must give the art director the cleanest picture possible to keep the retouching at a minimum. It will keep the integrity of your photograph and that somehow keeps you sane and makes you feel better.

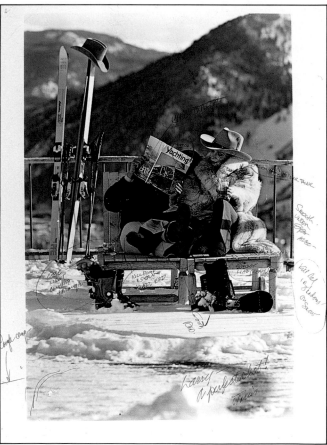

YOU DON'T GET WHERE YOU'RE GOING BY FOLLOWING THE HERD.

HANDCRAFTED BOOTS

DAN POST, EL PASO, TEXAS. CALL TOLL FREE 1-800-232-2263

YOU DON'T GET WHERE YOU'RE GOING BY FOLLOWING THE HERD.

HANDCRAFTED BOOTS

DAN POST, EL PASO, TEXAS. CALL TOLL FREE 1-800-232-2263

*L*ighting on location always presents its own set of problems, mainly because you do not have the same control as you do in your own studio. Location scouting becomes extremely important and as the photographer, you should always see the location in person if possible. Polaroids taken by scouts can give you an important first look, but nothing will serve you better than your own personal feeling for the place. Seeing it yourself is, of course, not always possible, so you have to overcompensate with lighting and set-dressing needs.

If you have a great deal of power need for location lighting, it isn't every private residence (or barn) that can accommodate. For the photograph of Jack Youngblood for Dan Post Boots, done for Kurt Haiman at Grey Advertising, we had two sets of 150-foot cables to bring in power from a nearby house on two different circuits. We also brought a portable generator with enough power for double the lighting I estimated. In the boardroom, it was no problem as the commercial building had almost limitless circuitry which is, of course, utopia.

The barn also did not look like what you see in the ad; it was a mess. As I mentioned, locations never turn out to be what you see in those original location polaroids. It's best to come prepared with more props than you need, while staying within the budget, of course. It's hard to come up short when everyone is sitting around waiting for your genius to get the job done.

You must also bring all the accoutrements for cleaning the place and setting it up the way you want. In this case, it was extra bales of hay, harnesses, barrels, shovels and pitchforks, rope—we even put the eucalyptus branch in the window. In the boardroom, we brought in the table, chairs, pitcher, and glasses.

So even though you seem to be on the ready-made location, you have to turn that location into your own controllable studio away from home. I cannot emphasize strongly enough that if you don't bring it with you the first time, you could be in very serious trouble by making your art director and client wait while you fill the bill. A great deal of thought and preparation goes a long way in making your life easier on location and making you a hero to your art director. But let me point out that what is even more important is that he be a hero to his creative director and client and that's what he will remember when he thinks about calling you again for the next assignment.

Sometimes an ad, a series of ads, or a campaign comes along that passes the test of time. Marlboro is like that. There are few, but the ads on this page for Monsanto are like that. They were designed by George Nakano many years ago—too many to mention, and I think George is now directing commercials. I think they stand up today for many reasons aside from the good art direction. There are no models with clothes and hair to date the pictures. They are timeless in their graphics and the locations are superb. They are also an excellent example of product illustration on location.

The original blue carpet picture was photographed on top of my New York studio; the New York City scene was photographed separately from another building and the two were married by our friend, the retoucher. The amazing part of the story was that we had to wait for nasty, smoggy days to get the skyline picture; I have never seen the city so clear and beautiful as it was that week. Because of schedule, we finally made the picture and again, retouching to the rescue. Retouchers can do

anything, even smog.

The original on the red carpet is the picture I preferred for the mood, but to show the product and make the photograph match the others in the series, the picture taken later in the day was used. Again, the guy who pays the bills wins. The Olympic Peninsula picture, aside from the physical logistics, was a piece of cake. All we did was bring in fog and the ferns. The light stayed the same all day. Probably the most difficult part of the photography, again aside from the physical, was measurement of the camera height and position so all the carpet angles appeared as close to the same as possible. It proved more difficult than imagined, especially on 35mm. There are some things that have changed since we did these ads. Certainly the New York skyline has, and from further research, I've discovered the dry lake bed in Arizona is now filled with water. I was devastated, as it was one of the best lake beds I've ever encountered and I've sold stock photographs from that take for many years since Monsanto.

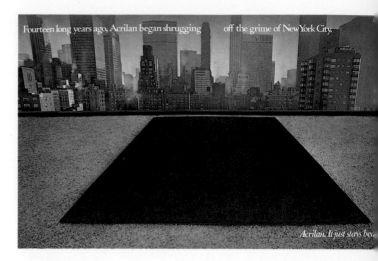

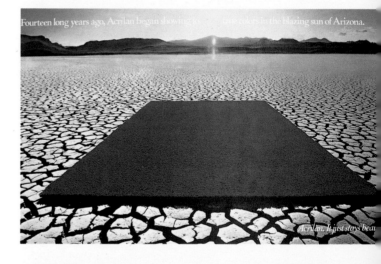

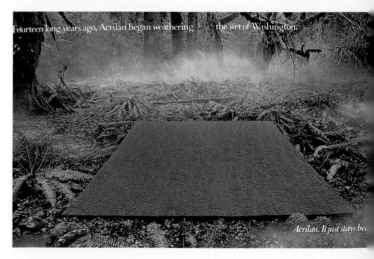

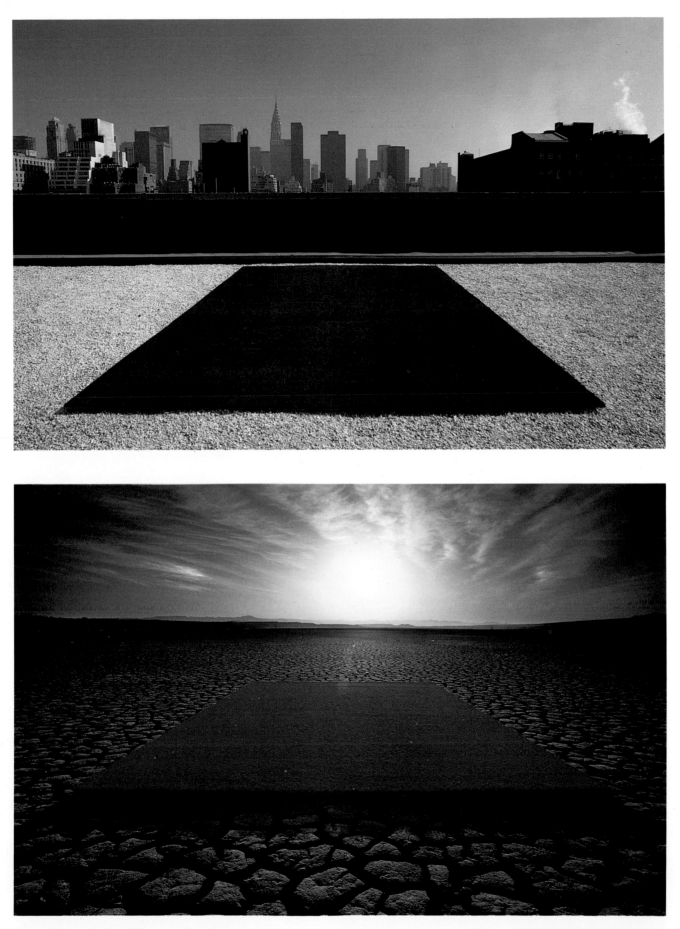

Monument Valley in the Southwest is one of my favorite locations. I photographed this ad for Seigel and Gale of New York under the art direction of Amy Schottenfels. The client was Captal Holding of Louisville, Kentucky, and they wanted Americana. An early cold spell and snowstorm almost froze our crew and the models, Bob and Velma Moore, who were not professional models but were cast from a Phoenix motorcycle club called The Retreads. Bob and Velma were real troopers and fought the bitter cold along with the rest of us in order to get this picture.

We designed a brand new vehicle for retireme

Nowadays, it's not unusual to see people over 55 traveling at 55.

More and more older Americans are taking nontraditional routes to retirement.

It's a fact that's been overlooked by a lot of companies that provide traditional pension investments.

But it isn't overlooked by us at Capital Holding.

We create retirement products that are as contemporary as our customers.

Consider our Indexed Guaranteed Interest Contracts, sold through our subsidiary, Capital Initiatives. We took a

conventional institutional investment vehi
up with a high-powered investment strate

By indexing our GICs, we give them
are always competitive with the market. Y
the guaranteed safety their name implies.

We also help millions of Americans
retirement with products from National H
other insurance affiliates.

Our single-premium annuities and i
make retiring on a company pension a littl
Our new variable annuities and life c

Capital Enterprise Insurance Group · Capital Initiatives Corporation · Capital Ventures Corporation · Common

88

ans.

ped it

es that

provide

ir own

d our

ans can

fortable.

ve peo-

ple a variety of investments to increase their capital while still offering the security of insurance.

And our UniversaLife™ insurance plans provide protection while paying current interest rates on the accumulating cash.

Naturally, products this innovative need to be sold with just as much imagination.

So we market our retirement plans through insurance agents, stock brokers, financial planners, pension fund managers and trust officers.

It's our talent for designing new-fashioned retirement

programs for institutions and individuals that's helped our assets reach $7.4 billion.

And given our customers the vehicles to reach their sunset years. No matter how they like to travel.

To learn more about Capital Holding and all our retirement products, write to Margo Barnes, Vice President, Capital Holding, 680 Fourth Avenue, Louisville, KY 40202.

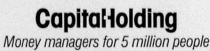

CapitalHolding
Money managers for 5 million people

ce Company First Deposit Corporation National Liberty Corporation National Standard Life Insurance Company Peoples Security Life Insurance Company Worldwide Underwriters

Both of these ads for Lady Speed Stick are well art-directed by Cindy Barnett, who was with McCann Erikson out of New York, but that's not the only reason I've shown them. Within these seemingly simple ads are many of the funny quirks of advertising apropos of what I've said about client involvement and the necessity of being versatile.

On the original layout presented to the client to sell the campaign the agency showed a dance room floor in a picture "swiped" from a magazine.

The client loved that floor and could be sold nothing else. We could not find a similar floor and windows anywhere, but in the process of scouting the entire world of floors, we found a superb location. The floor was still not acceptable, but the windows were, so a set builder was hired to build the floor and stain it to the exact color the client wanted. The funny thing is, we built it at the great location because the client loved the windows. What this all adds up to is a double cost on the location fee and a set

builder when it could have been built right at the set designer's studio.

The "swipe" used to sell the beach ad showed a beautiful and dramatic sunset and where else but southern California can you be guaranteed beautiful sunsets most of the year. Unfortunately, the day we were to photograph we had a deep and solid fog bank resting just off shore, obliterating the sun. I pushed to take advantage of the situation and a call was made to New York to the next higher-up and, because of an already

stretched budget, the go-ahead was given. We worked in the fog and the sun, of course, burned through the fog at sunset as we were wrapped and on our way home: Murphy's Law.

Both the agency and client were pleased with the results and as always, I felt picture selection could have been more to my liking, but then again, I always feel that way. But you must be able to adjust and innovate, move quickly to make the picture within the time allotted and the budget and fees paid.

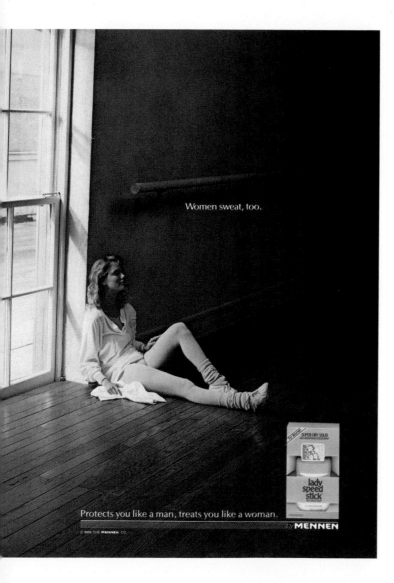

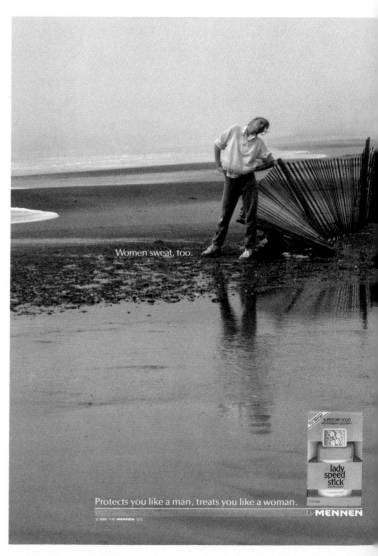

Here is an example of an adventurous art director and a cautious client. Gery Jensen, the art director for Campbell Mithun of Minneapolis, created the idea, and the original picture shown is the one I preferred. The client, however, wanted the one without splattered paint used in the ad. It's still a good ad, but with a little adventurous spirit, it might have been more of a "page stopper" than it is. I do think their decision to change the paint color from red to blue was a good one. When there was a lot of paint, the red had a tendency to make it look like a remnant from some horror film. Gary had okayed doing the job on 35mm film, but I felt 8x10 would make it just a little bit more special. Model Heidi Helmer from Nina Blanchard Agency, Inc., made it special as well.

Have a great Woman's Day, America.

Her life is moving at full gallop. And the faster she moves, the more she needs Woman's Day to keep pace with her family and herself. She doesn't have time to wait for Woman's Day to arrive in the mail; she buys it where she buys your product—over 100 million times a year!

Woman's Day readers are active buyers, not passive subscribers.

Monument Valley is one of the most dramatic locations within our national borders. It actually belongs to the Navajos and is within the borders of the Navajo Nation. They believe it to be a spiritual place and I agree with them wholeheartedly. The client, Woman's Day, wanted an Americana theme for the campaign. They found it here, and on both coasts. I was fortunate in being assigned Monument Valley and San Francisco; Avedon did an enviable and wonderful photograph under the Brooklyn Bridge. It was a nice campaign and I wonder why they've ceased to use it.

For the Monument Valley picture, I used straight sun as my light source, as I needed the fast shutter speed for a moving horse, two bouncing models, and coordination of the background from a moving vehicle. This is all fairly difficult to do on a slow shutter speed with Kodachrome 25. So, even with all the above going for me, I still felt the need to go to Kodachrome 64.

It's a matter of getting everything you can going for you without compromising the integrity of the picture. The direct sun works in this instance, whereas most of the time it is something to be avoided. I preferred the picture where the Mitten monument was not directly behind Dani Mennik, but I think the agency chose this picture for the models' expressions. It's always tough to get two models looking good at the same time, especially while bouncing around on the back of a horse. Dani was no problem as she is a pro, but it was hard with the little girl who was practically sitting on the saddle horn.

Have a great Woman's Day, America.

I needed a different sort of control on the cable car picture, so we hired a special photographic cable car made for this kind of situation. Since the car is on wheels and tires, rather than tracks, it can be placed exactly where you need it for light and background. I didn't want direct sun in this instance because shadows would complicate the interior of the cable car, cause reflections, and make the girl squint.

We photographed a second situation, which I preferred. It brought more emphasis to the girl, but the client liked the cable car picture because the car is such a nationally recognized symbol of San Francisco Americana. He won, as clients sometimes do, but the point is that we gave him a choice.

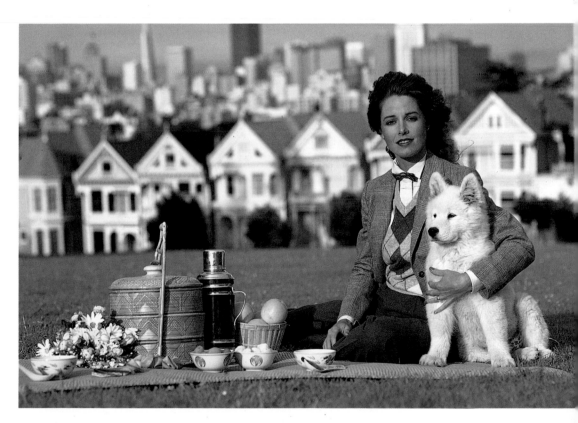

*C*oca Cola is a giant in the advertising world. They spend money, and they find the best in the business. This billboard and point-of-purchase campaign was the brainchild of Glenn Jacobs of SSC&B New York. I think it's great copy and a superb layout. Again, the emphasis was on the natural and the outdoors, all available light and Americana. All the location scouting was done specifically for light direction and graphics. However, there were always several options at each location, which is a wonderful asset if you can work it out. On the Jeep shot we had

two barns and several out buildings to choose from with regard to light. The art director argued very hard for an old Jeep and open doorway of the barn in full sun. I did too, but I am not, by any means, disappointed with the photograph they used. We worked in complete open shade from the background barn. The scene was filled with four 4x8 foamcore boards. We tried silver reflections, but it took away the natural feel and we deferred. The Coke can, dog, and jeep gave the model a good setting, plus he was a very natural guy so it all worked. One battle I

won on this picture was to keep the ivy in frame. Some of those involved wanted the camera moved to eliminate anything that might confuse the product logo. I felt we had to break up all the gray barn siding to take it out of the studio. I think it worked.

As you can see, there is just about every type of outdoor lighting possible in the series of billboards on these pages: direct sun, open shade, backlight, and variations on those themes. Our thought was to approach each location loosely and take advantage of anything that struck our fancy.

We did have layouts and specific ideas, but for the most part kept an open mind and tried many different situations within the given location. The only unfortunate part of this is that most of the pictures will never see the light of day on the printed page. We did have a great woman with us from Coca Cola in Atlanta, Maria Phillips. I'm sure, had she the choice, every situation we photographed would have been used. She was a great client to have on location; she made decisions, didn't panic, and most of all, kept her sense of humor.

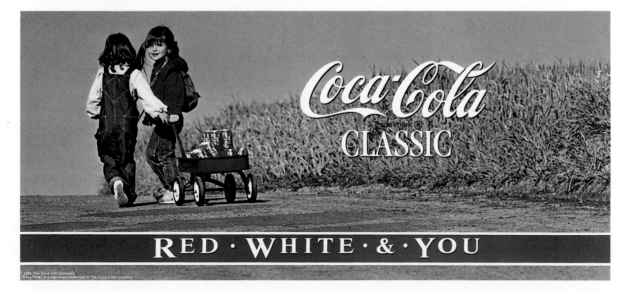

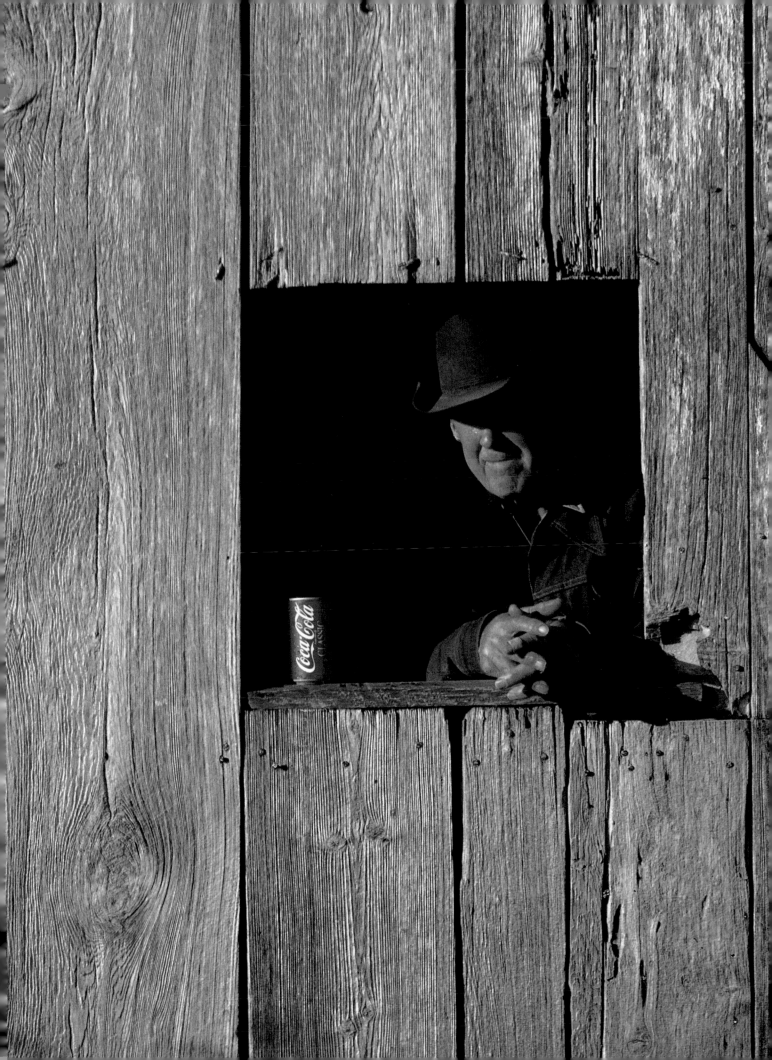

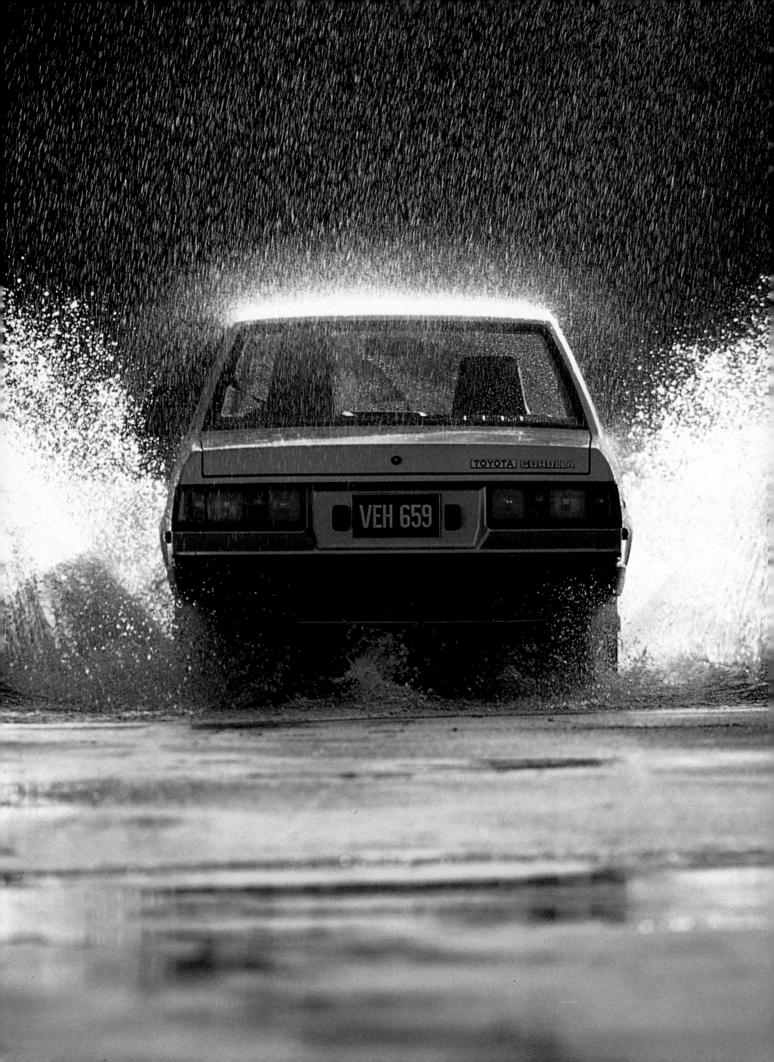

SHEET METAL

In an arena filled with many types of photography, I think working with the automobile may be the most specialized. It has been my experience that photographers who work on cars do very little else and rarely experiment with other things. The reasons for this are many and I'd probably have to be a psychologist to find them all, but if most "car guys" want to photograph something else, it is probably beautiful, nude women! They really could do both; it's just a matter of unlocking the creative door and trying. After all, both subjects come to life under one thing: light. Skin is just not quite as reflective as the mirror surface of an automobile.

One thing is certain, these gentlemen have an affinity for "sheet metal." *Moi aussi;* I just don't want it to be the only type of photography in my life. I like variety in my photography as well as in my life. You need to look at things with a fresh eye now and then to exercise your creative muscle.

Having been brought up in California and lived in Europe, automobiles have always been a part of my life—and I do *love* cars! Photography of cars came along at the hands of art director Dave Miller and Boulevard owner/photographer Jimmy Northmore. (The Boulevard is the largest automobile photography studio in existence. It is in Detroit.) Dave put Jimmy and me together as a team for photographing people with cars for Datsun catalogs. I was to cast, style, position, and pose the models, while Jimmy dealt with the cars and the 8x10 camera, pushing through the sheets of film. I also photographed many of the smaller detail pictures on the cars. It all worked very nicely, but I think both Jimmy and I were a bit embarassed by the whole episode. The catalogs were beautiful, but I knew I wanted to get at that big camera and the "sheet metal." I've worked with 8x10 and 35mm in the studio and on location ever since.

I love the location side of the business. "Sheet metal" work supposedly means work at dawn and dusk and long hours during the middle of the day at poolside. However, in reality one is usually involved in such trivia as location scouting, looking at yesterday's film, having endless meetings, and taking phone calls about your next job while praying that the schedules don't conflict.

Two particularly fine accounts I've had (Toyota and BMW) allowed me to do the things I do best: location lighting, people, and action. Running the cars in the light of the setting sun, working from an equally fast-moving camera car—it's magic.

Although the 8x10 format makes the product look better than life, it cannot give you the spontaneity and naturalness that 35mm can. But there is magic both on location and inside the studio with both 8x10 and 35mm in "sheet metal" photography. It is a specialist's world for the most part, but again, like all photography, it's still made up of all the basic elements of making pictures. Learn to work with light and you really *can* do it all.

Toyota has been one of my best clients over the past few years, thanks to the Dancer, Fitzgerald & Sample Agency in New York, and to art directors Scott McNamara and Bob Adams.

Working with Scott has been a great pleasure through the years. He is one of the most stoic and un-flappable art directors in the world of advertising. The joy of the account was being able to work with cars on 35mm, at least for the most part. There was some 8x10, but we worked the action with the small camera. I've always felt it gave the photo-graphs a more real and believable look. Toyota has since moved the creative end of their campaign to Dancer, Fitzgerald & Sample in Los Angeles and they have initiated a more 8x10 "Detroit" ap-proach, eliminating the small camera work.

The truck shot shown here was a little too moody for the client, so a picture taken earlier in the day was used, but I loved the feel of the moody picture. I also liked seeing the model, who gave life to the ad.

Here are a few of the ads I did with Scott McNamara; they show a good variety of situa-tions, locations, and lighting, but they are all action photographs. They show you how the theme of a campaign can work. We also used a variety of "extras" like Fuller's Earth for dust, water trucks for rain and wet roads, and many times worked from camera cars for car-to-car action and blur-red road surfaces. It was always a challenge and an ex-citing account to work on and I was sorry to see it go the way of most automobile advertising; I think they had a more unique approach in those early days.

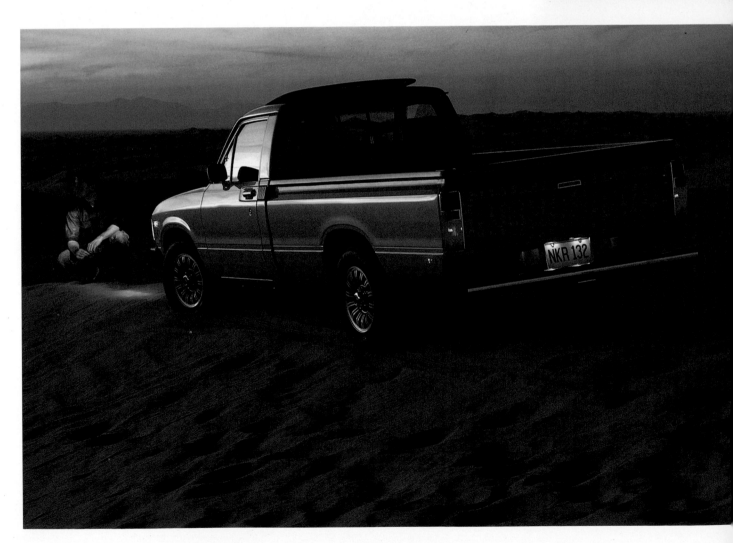

Here again, you see the look of a campaign. We won awards for this one, plus it was a dream account to work on. Wonderful locations, filled with numerous, potential ways to photograph the car and make it look sensational. Most importantly, the pictures and the campaign sold a mood and a feeling for having a Jeep, not just the car as an inanimate object. You could do these things "Only In A Jeep."

Even though the campaign was tremendously successful, the creative end was again moved, this time back to Detroit, and the whole approach was changed. It's another of those decisions I'll never understand. This campaign could have been as long running and identifiable as Marlboro.

The agency at the time was Saatchi & Saatchi Compton in New York; the art director was Joe Budney and the creative director was Bill Harris. We all worked hard, covered a lot of miles, and saw a lot of sunrises and sunsets. It was truly my kind of campaign. The most important components of it all were the locations. Many weeks were spent finding just the right situation, especially the island—that proved to be a real challenge. We were all worried and conjured up all sorts of solutions, even the idea of building an island in a workable body of water. (The cost was too prohibitive.)

But here is an illustration of why a photographer should always look at his locations and study all the alternatives. We were on our way between setups and passed a big lake called Isabella and I remembered it from the location files. We stopped, I dug them out and had a look. According to the pictures there was nothing, but I had a feeling. We drove the few miles around the lake and there was our island. We came back several days later and did the shot. We brought in everything: rocks, bushes, the tree, and we used model/actor Ron Hayes throughout the campaign. He was superb. We were even able to drive the Jeep onto the island with little effort. The place was as near perfect as possible. A little tenacity goes a long way.

I included a picture that never even made it to the printed page. We had pictures and ideas that could have kept the campaign going for several years. The lesson here is a hard one; even though you seem to contribute much more than is needed, advertising is a game of parts and many of those parts will not be used—ever. This is the frustration of advertising; not just for the photographer, but for the agency people as well. Remember, they work long and hard for weeks and months on a project before you, as the photographer, ever enter the picture. I think handling all the frustrations and changes goes along with the money and reputation you gain from doing major advertising work. You just do not get something for nothing; there are dues to be paid. It is all part of being versatile; you have to be able to handle all the peripheral paraphernalia that goes with the taking of and making the photographs.

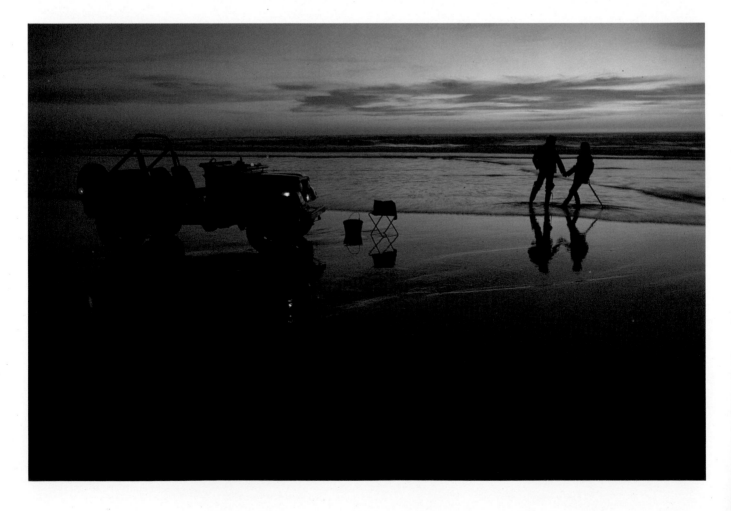

Ameratti & Puris is a small but mighty agency in creative advertising. Their work on BMW is recognized as some of the best in car advertising. I worked with creative director Jerry Whitley for a short time on the campaign and it was an experience.

The picture of a trio of BMWs was done on a race track hired for the day in upstate New York. We needed the track because Jerry wanted enough speed on the cars to make them really lean in the curve. This meant speeds of up to 90mph. To get the right angle, I had to be in the middle of the track, on the pavement and immovable. The 300mm Nikkor lens gave me some room, but the middle car had to brake at a marked spot after the curve and duck in behind the car to his left. All three went past me at just about full speed as braking in such close proximity proved to be even more dangerous. It was great fun, but very spooky. The shot won both praise and awards everywhere. We used Fuller's Earth to make the dust cloud behind the cars. At that speed, we only needed a narrow strip of the "dust" at a point behind the cars.

The single motorcycle was photographed from a camera car on a mountain road. Since we couldn't satisfy ourselves with the perfect road, the background was a separate picture, stripped in after the fact. We photographed the second road with every conceivable lens, filter, and lighting situation to give all the possible options.

The twin bikes were done on a race track from a stationary position. There were many problems on this assignment and I had to reshoot, never really satisfying myself or my art director. I liked the picture, and liked others he didn't use even more, but I never worked on the account again. You are, as they say, only as good as your last job.

This picture was done with Bob Adams of Dancer, Fitzgerald & Sample in Saudi Arabia for the Saudi Toyota distributor. The ad is a great example of being versatile in all ways, especially outside the actual taking of the photographs. The trip to Saudi Arabia was tough, to say the least. We were dealing with people who did not understand the urgency of what we were doing. Delivering a clean car for photography meant little to the dealers, who felt they would sell cars no matter what (and they did).

We also had to deal with a language problem with drivers and personnel to help clean the cars. And we had to deal with the heat, which ranged from 90 to 95 degrees when we went out for dawn sessions at 3:30AM, to 130 degrees for the afternoon sessions. Keeping film cool, as well as people, became the prime concern on the trips. And, getting workers up for 3:30AM calls was unheard of in this part of the world. We were running late most mornings, until I learned to make the calls thirty minutes to an hour before I expected to really get going.

One thing we never had trouble with was the light; it was clear, blistering sun every day, day after day. At dawn we were through with main pictures by five minutes after sunrise, flew large parachutes for the detail shots, and usually would be back in the hotel air conditioning by 10:00AM. The assignment was an incredible example of adaptability. One assistant I took kept saying "no problem" when I asked him to do something. He very soon learned the real meaning of problems and was a better assistant when he arrived back home.

One of my premier assignments with the automobile was for brochures with Gene Butera, creative director at Campbell Ewald Detroit, who took us to Germany and Italy with two Corvettes. It was a trip fraught with frustrations and problems, but also filled with the ambience of Europe, German beer, autobahns, very fast Corvettes, pasta, and the joys of Rome. Many a night Gene and I buried our frustrations in *spaghetti alle vongole* and good local wines. Actually it wasn't so rough after all.

What the job really entailed was tenacity. Although the Germans got our car out of customs in two days, the Italians were another story; it took nearly ten days to clear the car. With the clock running on all these people in Italy, it was maddening. I think Gene appreciated it when I took myself off the clock and went to the South of France for five days. In the end we did some great pictures of the cars and Gene's brochures were a work of art. Both pictures were done on 4x5, rather than 8x10, as we tried to keep the weight and logistics down due to all the travel involved. We couldn't find our castle in the southern area of Germany we started out in, so Gene and I took the Corvette and set out with map in hand on the famous

autobahns of Germany. After two days of driving and looking at castles, we found the one you see here. It was a special place, enchanted to be sure.

We set out to do the Italian picture in Florence because Gene knew the city had exactly the piazza he wanted to use. When we arrived we discovered it just wouldn't work. The car was also in customs in Rome and having lived in Rome for over a year, I suggested we get to Rome as soon as possible, or we'd never get the car or the picture. Gene, loving Florence, reluctantly agreed and off we went. After what was probably hundreds of international phone calls and numerous trips to the customs offices, we finally got our red Corvette. We did the shot in one of the busiest places in Rome, the Piazza Navona. There were seventeen models and a crowd of several hundred behind me watching; it was madness for about two hours. I was never so happy to see a picture "in the can" as I was on that crazy day in Italy—pasta or not.

The schedule demanded that Gene be back in Detroit so he was long gone by the time we got the picture. It was a real vote of confidence from Gene for him to head home when a major shot was still unresolved.

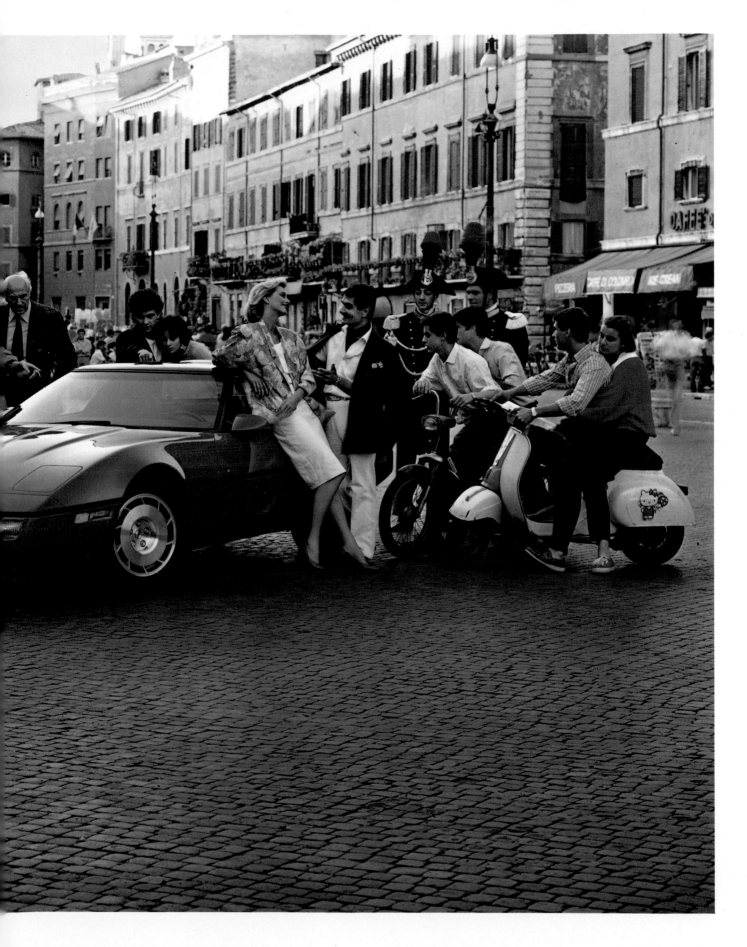

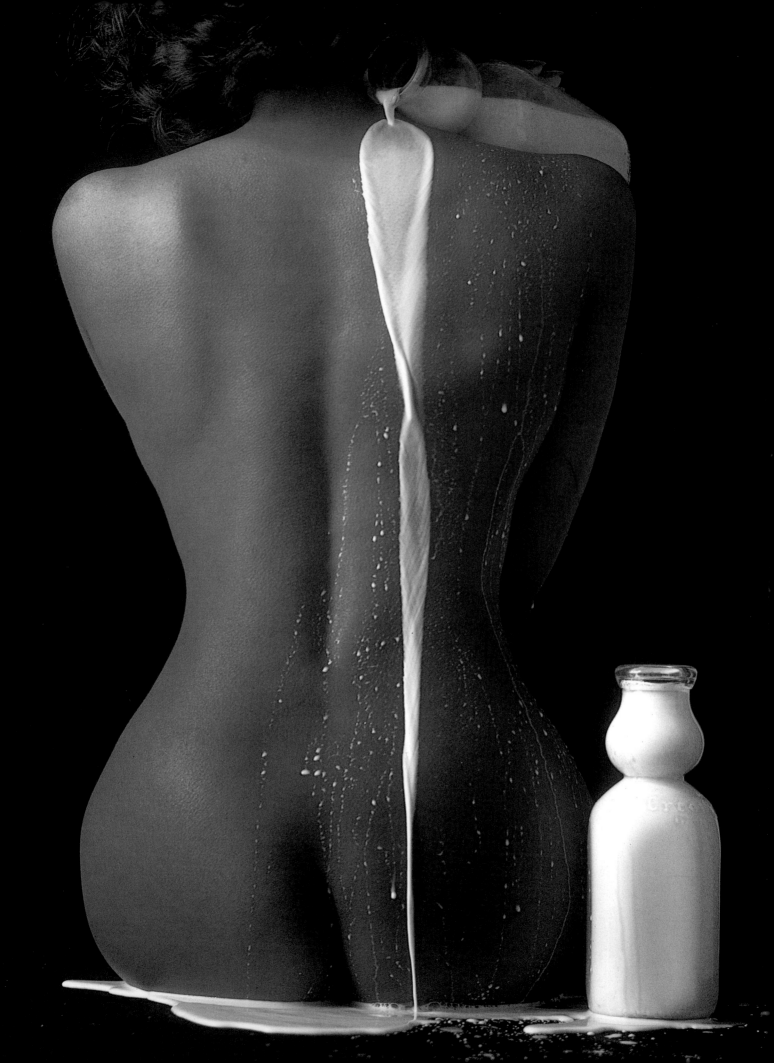

WOMEN (UNCOVERED)

The nude has been a part of my life almost from the beginning. My first photographic show was at the Festival of Two Worlds in Spoleto, Italy. The exhibition consisted of experimental nudes photographed while I lived in Rome during the sixties; the framed prints sold for $25. The female nude is probably the most-often illustrated subject since man began scratching on the walls of caves. She has survived centuries of both glorification and artistic abuse, and remains a timeless theme.

I've worked with women both on location and in the studio and my preference for the setting depends on the woman I'm photographing; for the most part, they will dictate where you go. If the location comes first, I try to pick the woman to fit the place. Wherever it might be it's always a joy and a very special experience. The woman can be either an integral part of nature, or apart from it—a graphic design within her own structure, her own texture, her own being. One thing is certain, the less technical the set-up, the more real the girl will become. Working in a two-dimensional medium already puts you at a disadvantage, and the more elements added the more it takes away from the realism of the woman. The exception to this is the experimental set-up where you plan to take her out of reality.

And always remember, sexuality and sensuality do not mean complete or overt nudity, as characterized by some magazines we are all familiar with. Women are a very special group of people; treat them with respect as equals. You will gain more than you can imagine, in your pictures and in the personal experience of friendships as well.

This set-up was in a gym I had built into my hillside home of more recent years. Jeana has also been a long-time friend and doesn't do nudes for too many other photographers. The reason I emphasize my relationships with these women is because it's one way to establish the rapport you need to make these kinds of pictures. If the girl feels comfortable and you the same, it's just going to be easier for you both. That is not the only way, to be sure; you may have to establish the relationship in minutes or hours, especially on an assignment. I've not done too many assigned nudes. Most of what you see here is self-initiated.

I've always been fascinated with the female nude in many ways, but extreme backlight is of particular interest to me. It was a technique I experimented with way back in the early years in Rome and exhibited in Spoleto. It was my beginning with nudes and it was filled with the joys of discovery for a young photographer in Italy.

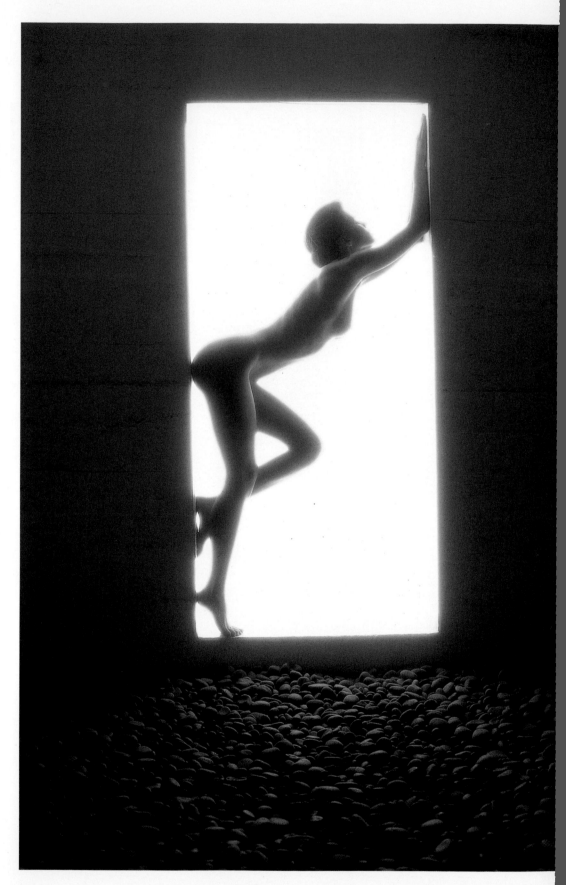

All still life and product photographers have light tables. I have one as well, except many times my product is the female form. My dream is to have a seamless light table with grand enough proportions for full figures. This picture is somewhat less ambitious, but nonetheless appealing. Sometimes less is more, as they say, and partial anatomy is always more graphic and even more mysterious than showing it all.

OVERLEAF

I took this photograph at maison Gordon at Petite Taillat in France. The idea actually came from the colors and graphics already present in the scene. I added the girl, but even the red towel was there. It's a matter of seeing potential pictures as you pass through every-day life, whether it be on a beach in St. Tropez or on your own home-town street. The pictures are sometimes there, intact and ready, or sometimes they need to be coaxed out.

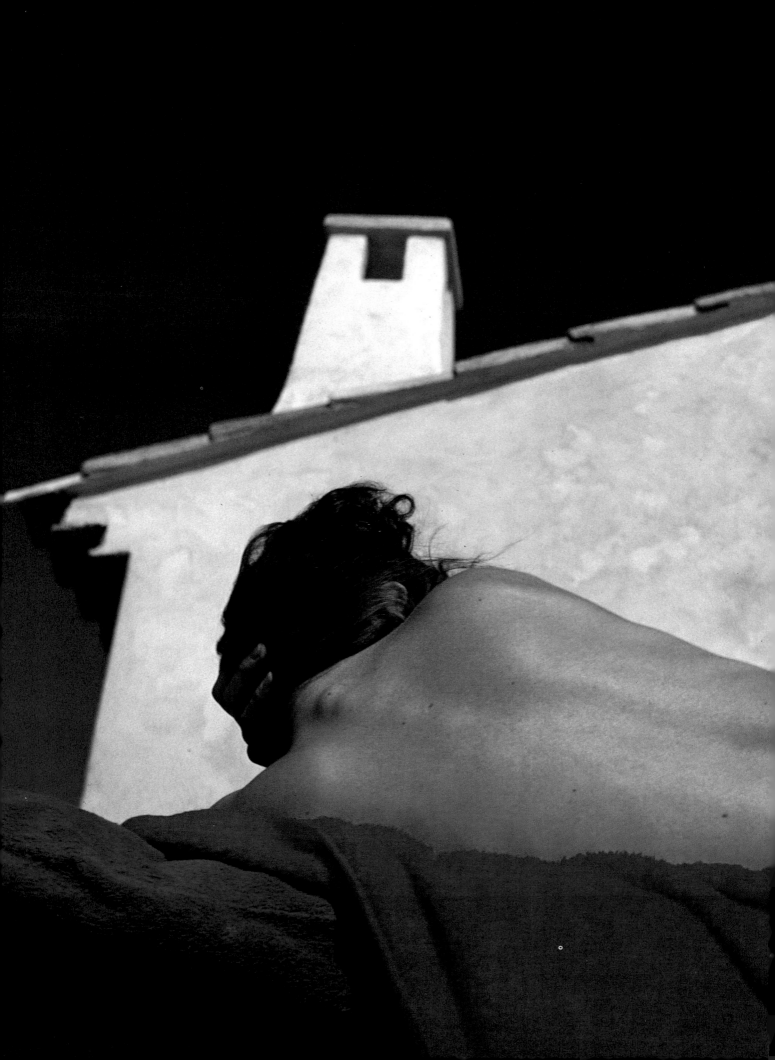

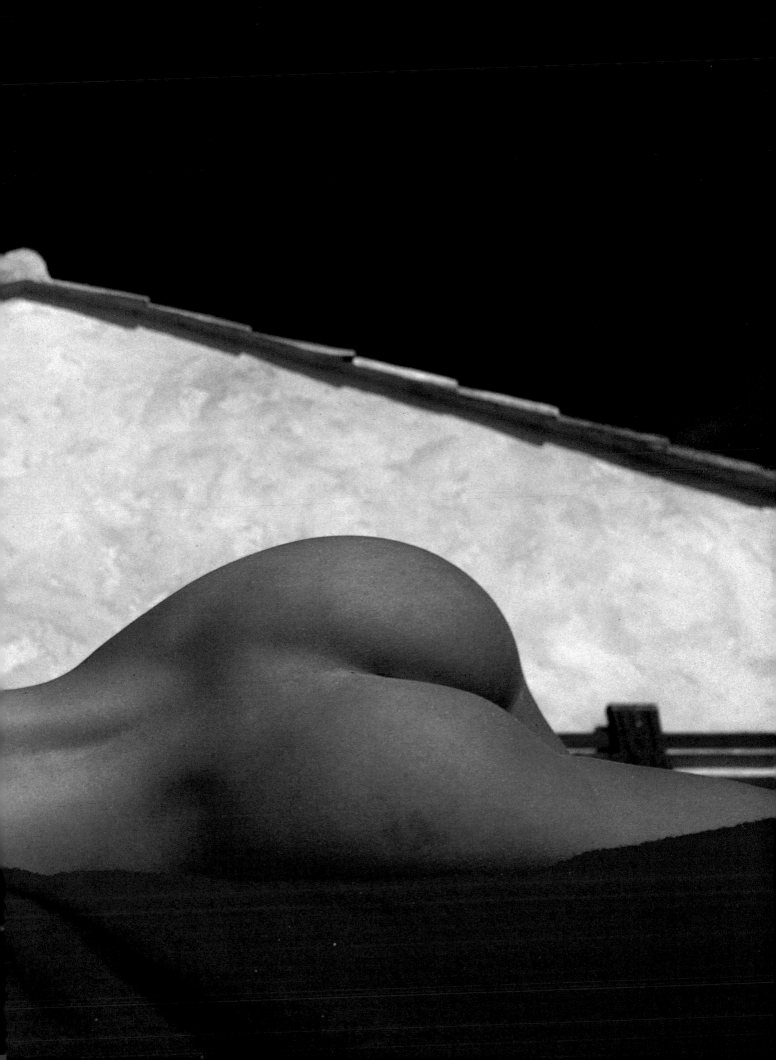

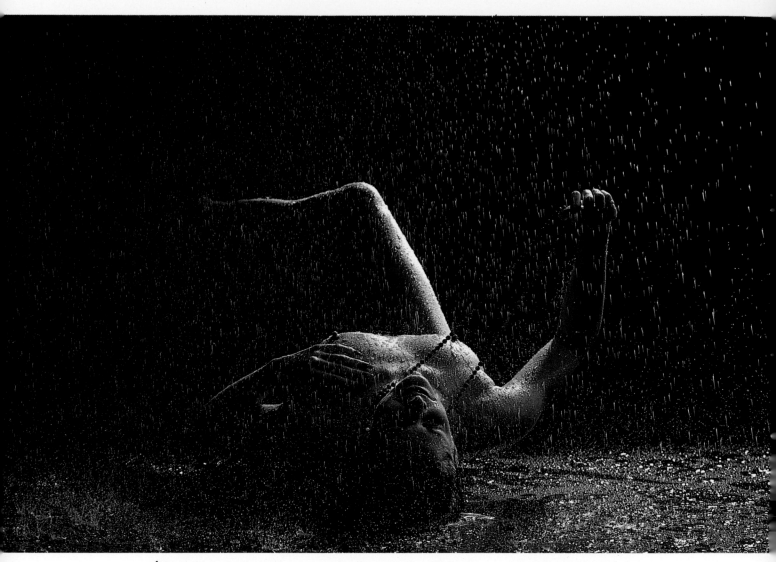

All the pictures in what I call my "Raintable" series stemmed from my time with wet women in the early days. Since then, I've always been fascinated with water and other liquid properties in conjunction with the nude form. Somehow they go together, all being elements of nature and our creator. In this series, I wanted to marry all these elements together: one of the best forms created, woman, along with natural elements,

especially water. I've used both artificial light and sunlight, which has given me a great variety of looks and I still have a long way to go. There are lots of ideas swimming around in my head—trying to find time to get them out is the tough part. That's always the difficult part of a photographer's life: finding the time to experiment and do things for yourself. But it's a must if you want to grow and learn.

We heat the water, which makes life easier for the models. If you don't, you can't use a model for more than a few minutes. My feelings about these early pictures are negative only in that we did not go far enough and things are too literal: the table, the rain, the girl, the poses. But I still love these pictures, including the one on pages 116 and 117. Later we varied the theme, netting very different results.

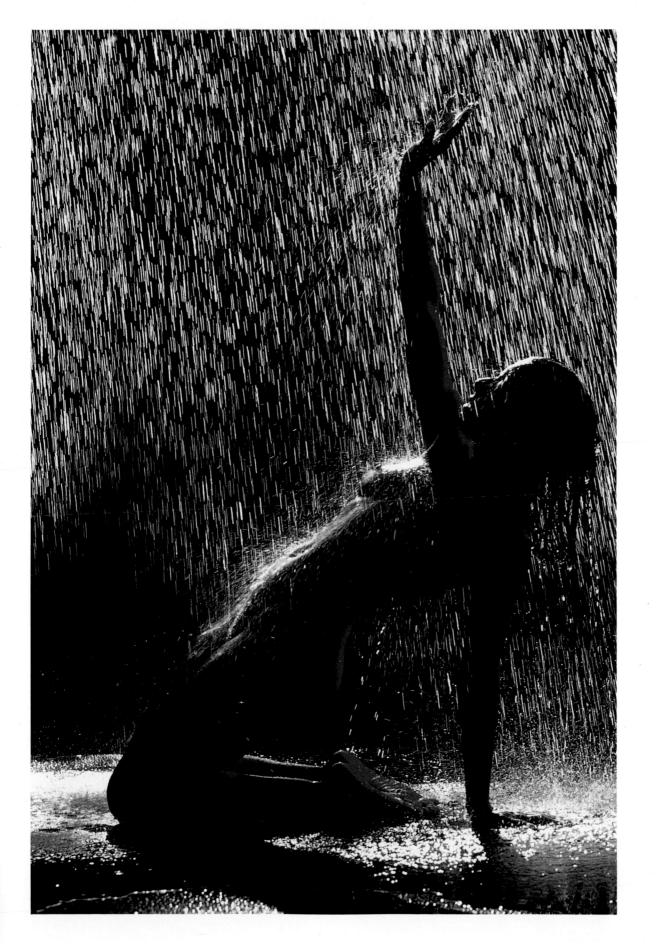

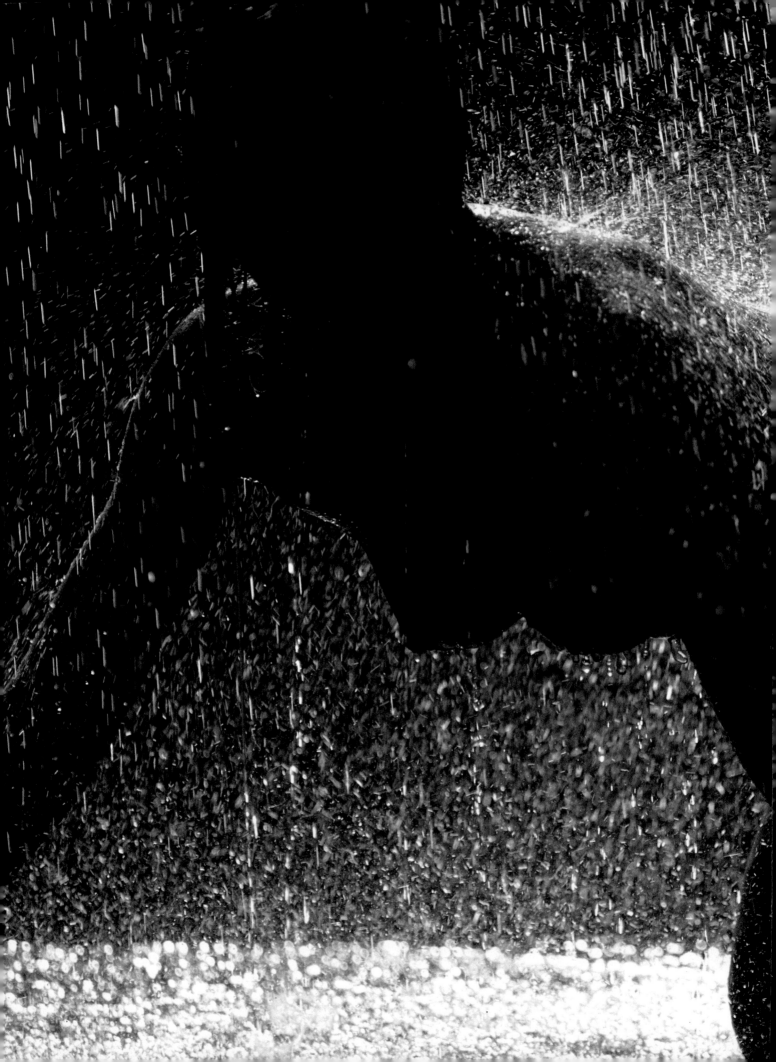

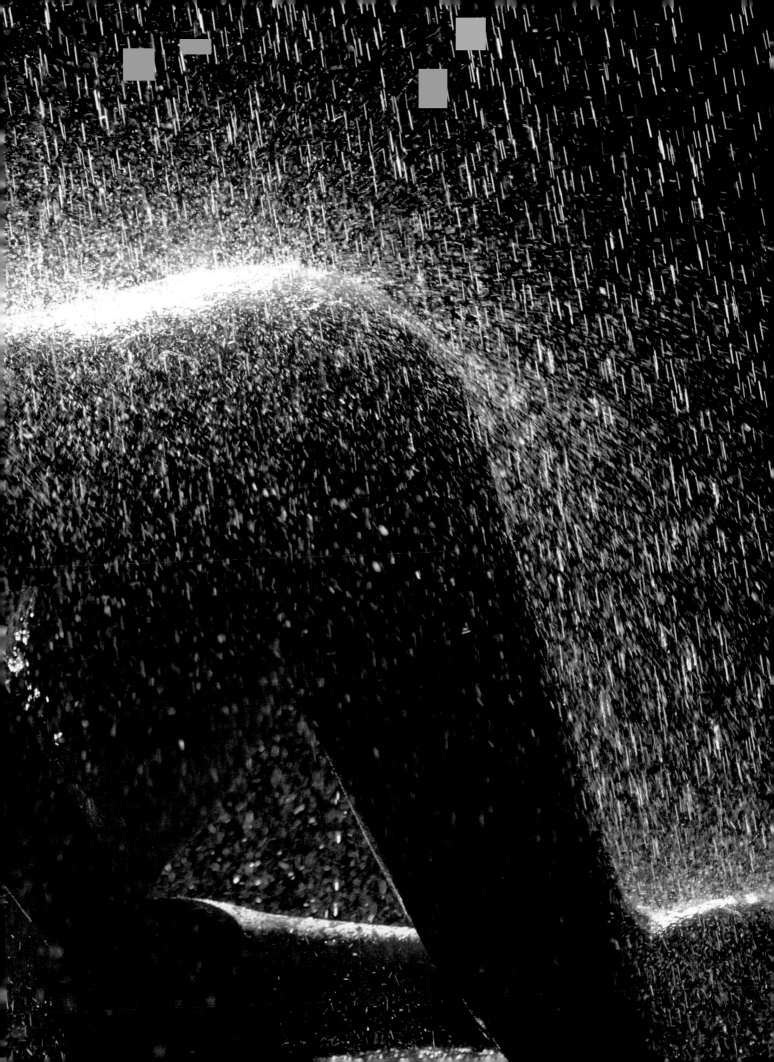

When you are experimenting and/or doing things for yourself, it's best to find the money, pay the girl what you both think fair, and get a release. Trying to do it later, or even worse, trying to avoid payment, will net you so many headaches your mother will feel the pain. Just don't do it; don't be devious as many photographers are who deal with young, naive girls and nude photography. Be up-front and pay for what you get; without her, you get nothing. Most of the time you can retain a long-term friendship, which is worth much more in the final analysis. She will then work for you again and again, as she knows she can trust you. Be a gentleman and a credit to your profession; it's rewarding.

The black or very dark backgrounds always work more effectively with the rain. I keep experimenting, but always seem to go back to the black, as with the pool.

Be sure of what your model can do before you make the booking and set up your picture. Otherwise, you will be in for some rude surprises that may cost not only your time, but your money as well. It will also cause strife, which never results in good pictures then, or at future sessions.

In this business of photography, there are sometimes happy accidents. Any photographer that tells you he doesn't take advantage of these occurrences is just bending the truth. I was in Cabo San Lucas with a lovely girl who has a truly wonderful figure, but has a bit of trouble moving and posing. One has to literally move her into every position with care, which takes time and still doesn't net the best results. We made this picture on a rugged beach, with the wind and a bit of fabric. Everything was going for us at that moment: the right sun, enough wind, warm water, the beautiful woman, and a incidental prop that really made the picture. I'm not saying that we wouldn't have come back with other pictures; certainly we would have. But by using a little imagination, ingenuity, and tenacity, we came back with something quite unique. Photographing women with fabric is an old idea and has been done many times, but putting it together with the seawater and wind and juxtaposing the girl in a coarse landscape, takes the idea just a bit further and the result is very special.

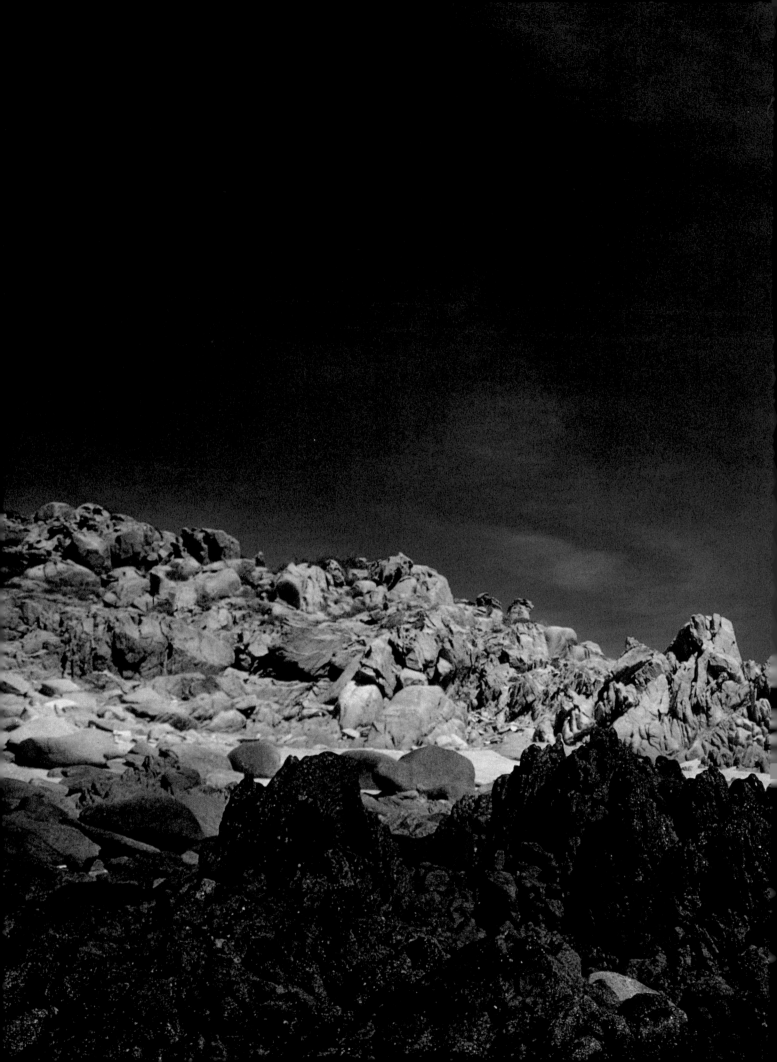

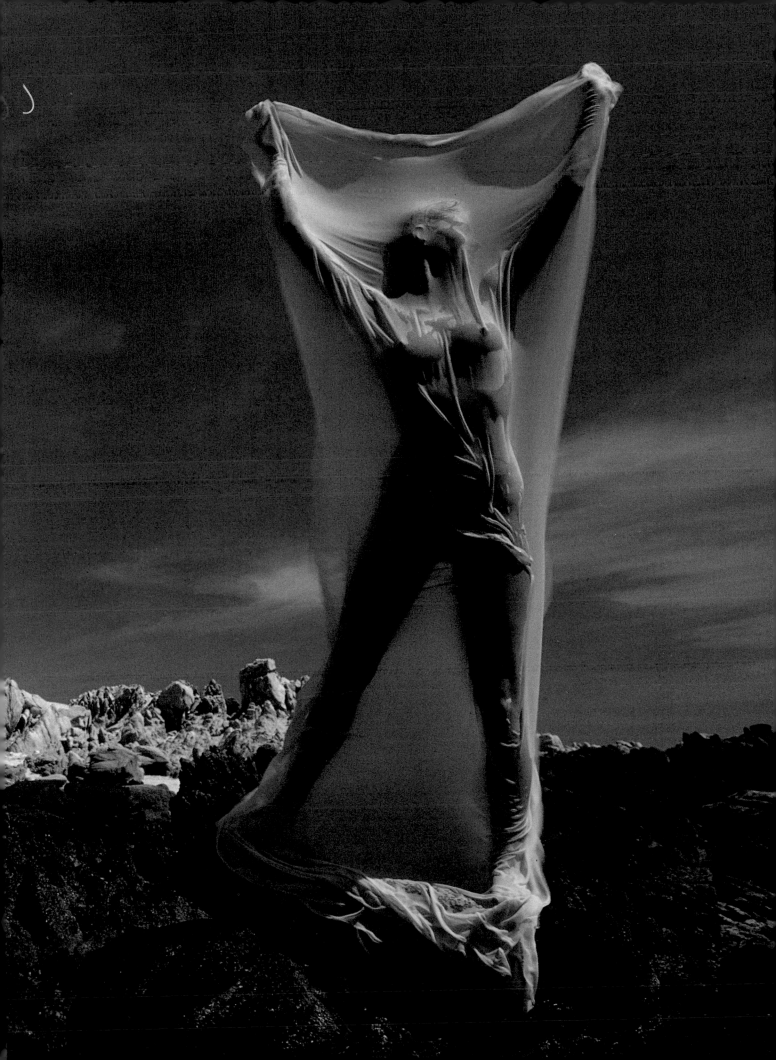

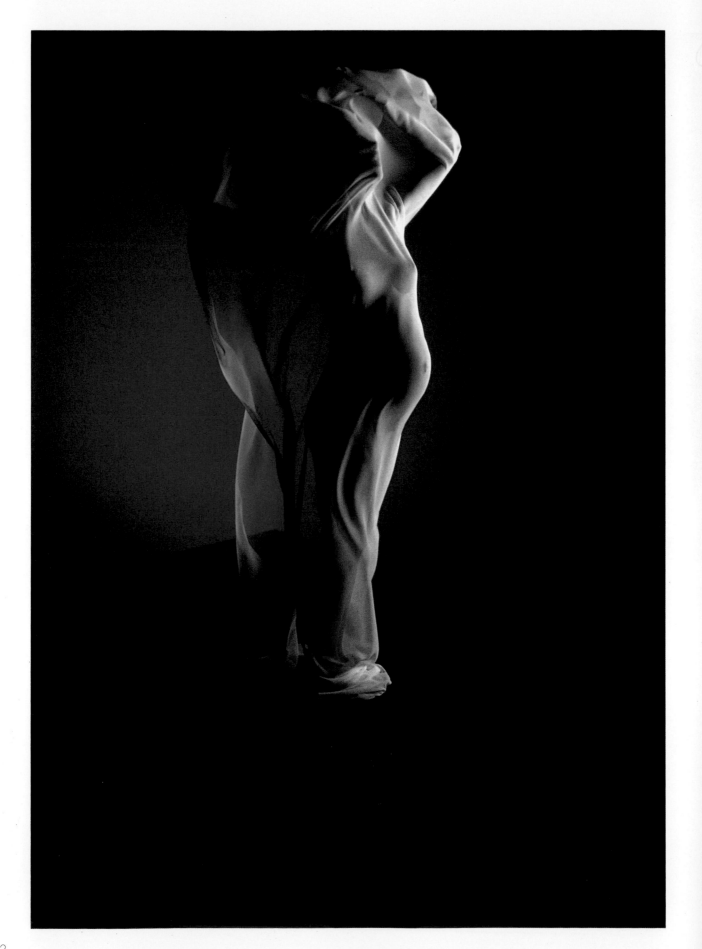

I've continued working with fabric in this instance, taking it inside the studio. These pictures were done on 35mm Nikons using Kodachrome and Norman strobes in a bank light. My models were Vicky Wilburn, and a great friend Jo Hayes, who happened to be pregnant with Matthew. We loved the pictures, but I'm not sure just where they're going—except in this book, of course. This was a situation of carrying one of those Happy Accidents a bit further down the line. Just remember that you can never get it exactly like you did that first time. It's like trying to rekindle an old romance or go back with an ex-wife or husband. If you try to do it differently, or better, you will come out on the plus side. Try to duplicate it exactly and it will fill you with frustrations. And who wants to work with formulas, anyway?

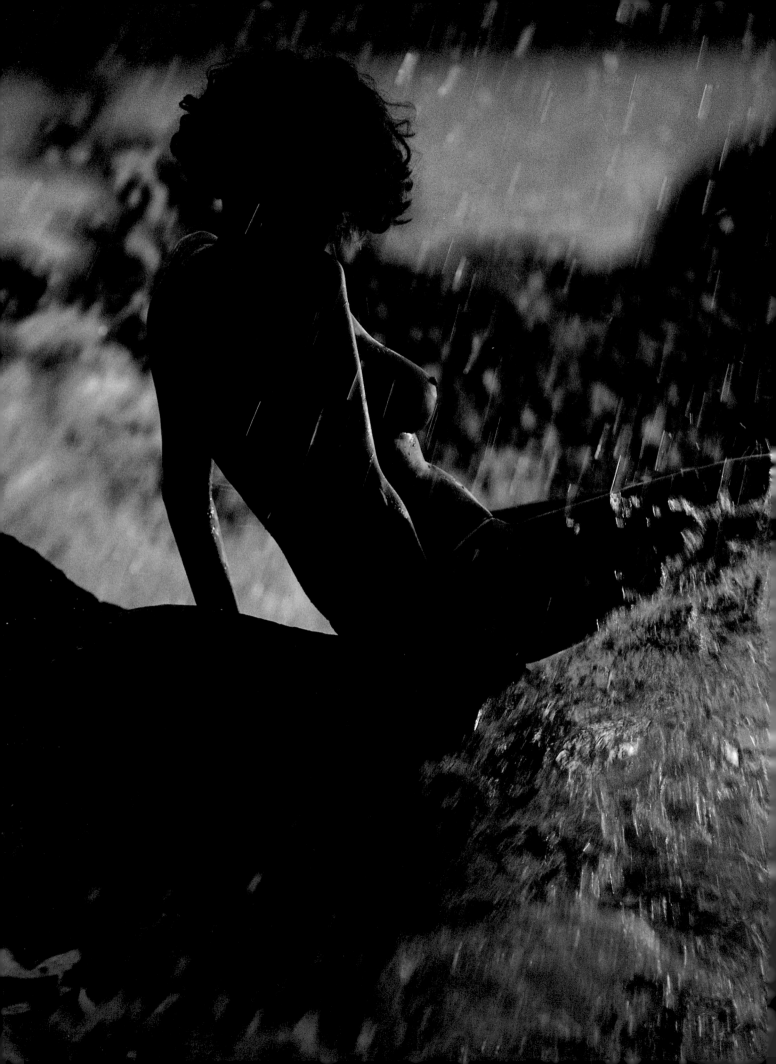

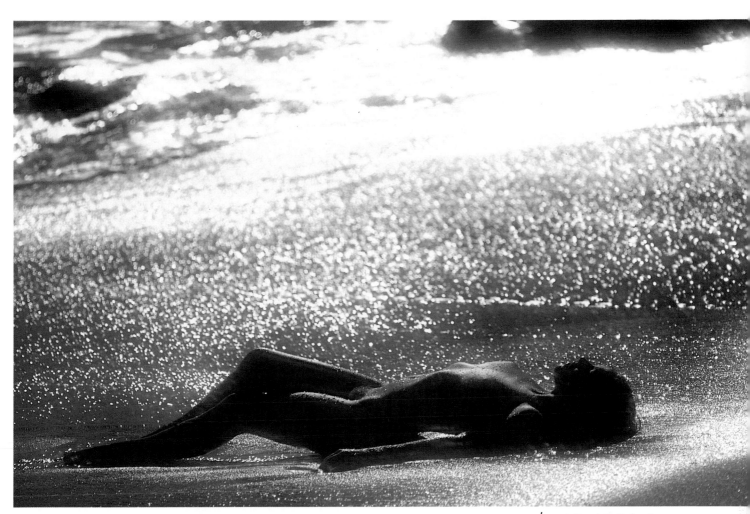

*L*over's Beach in Cabo San Lucas. This was taken during a lull in the action and the model was literally just resting; it was one of the best pictures of the day.

*T*his is Rose on the beach in Buzios. She was there, I was there, and so was the sea and the light. I just happened to have a 300mm lens on a tripod, waiting. I knew we would get a picture. We got many, but I liked the mood and sensuality of this one, with the rawness of nature coupled with the curve of Rose's anatomy.

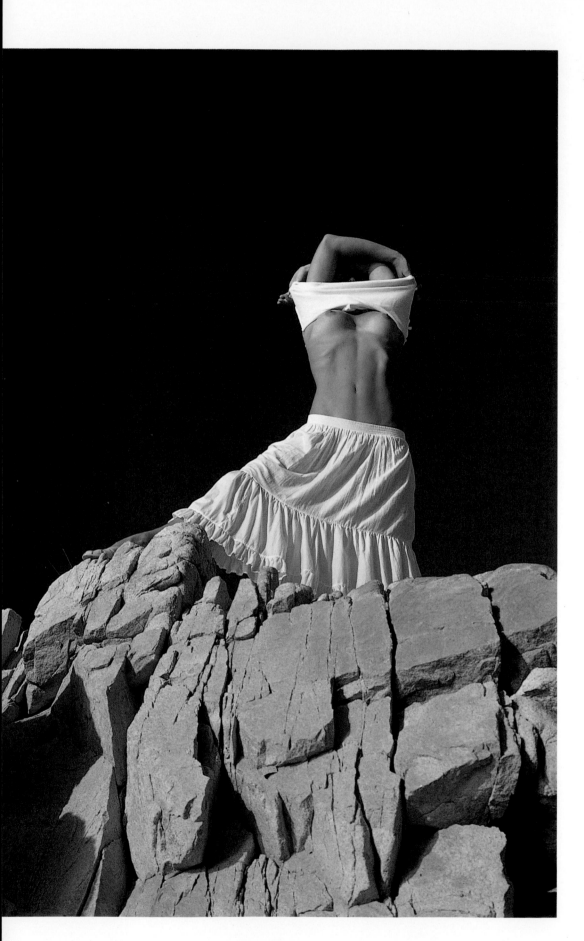

The two pictures here illustrate good use of textures along with graphics, one natural and one man-made. Vicky in the abandoned lighthouse window was done in Cabo San Lucas. Julie Wilson was on the same trip and the rocks are literally in front of the Hotel Cabo San Lucas, where we stayed (where I always stay). Both pictures were in direct sun and in both cases it works well, although the picture of Julie might have been better had I not polarized the sky quite so much. With that much white, light skin, and rocks, you need to go only a half or full stop under the meter.

I could have worked for days at the lighthouse. It was such a wonderful structure, sad to see it going to the wind and weather. Even though in ruin, the old building had a grand air about it, going down in dignity. I loved the place.

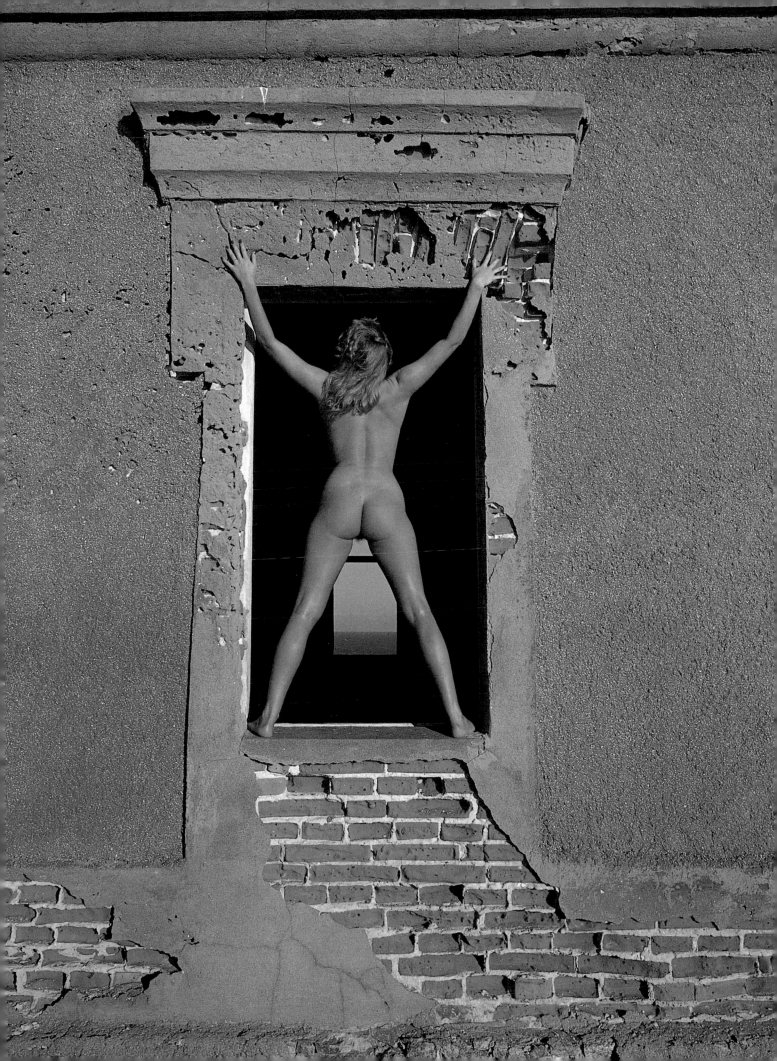

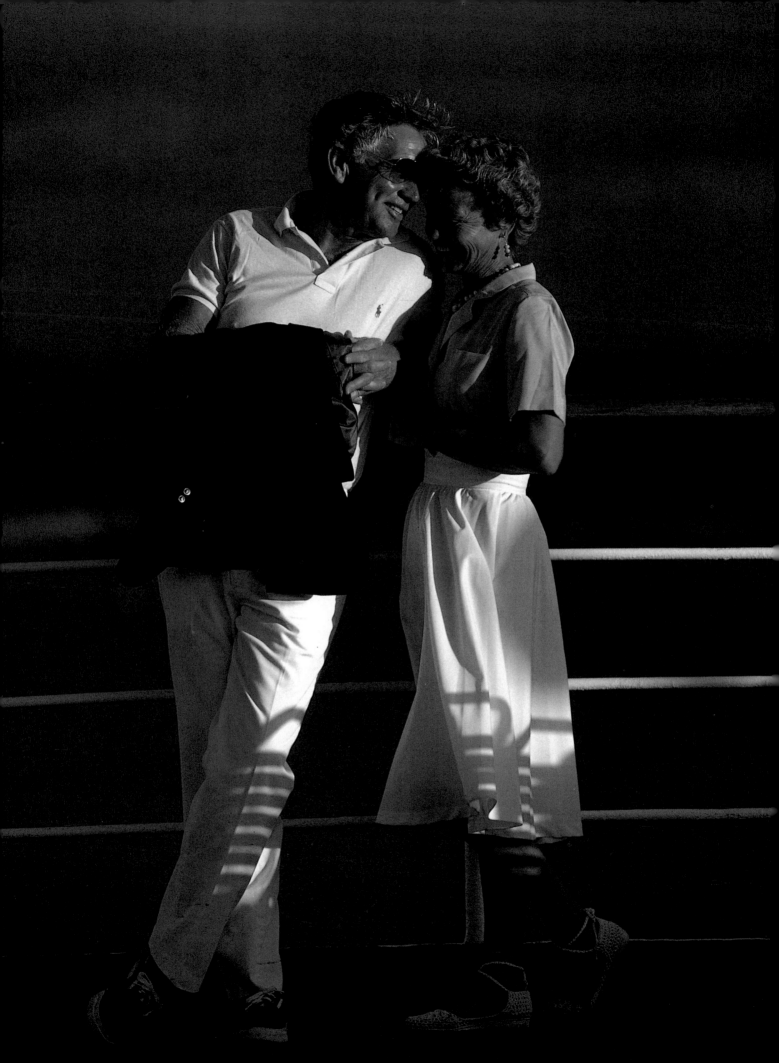

STOCK PHOTOGRAPHY

I have included this aspect of photography in the book because I believe it should be an integral part of a photographer's life. It certainly is an integral part of all our futures. The industry is changing and while I don't mean to reminisce here about "the good old days," it is different now and basically harder to make a profit. There are many reasons for the changes, but in simple terms it amounts to more photographers, fewer jobs, less money, higher operating costs, agency mergers, and very nervous clients. Obviously it's much more complicated than this and we could discuss it to death, but stock photography *is* a viable alternative, as many photographers are discovering.

There is no secret to building a stock file. One statement says it all: make and take pictures; pictures that will pass the test of time, pictures for the moment, and pictures that you love to do. Experiment, it will stretch your creative talent and believe me, all of us need stretching in this area.

If you plan to go for a stock situation and produce pictures, you must approach it exactly the same as you do any professional assignment: no more outtakes, only aim for the "cream of the crop." There should be a concept, a well-planned schedule, the best models you can get and afford, with the photography executed in the most professional way you know how. Start with what you do best and then go out on a limb and experiment. If trends continue the way they are today, it will be worth the effort.

I could write and illustrate an entire book on existing photography and the marketing thereof. For me it has become my annuity, my early retirement, my defined benefit pension plan—and it's a good deal more enjoyable than all the aforementioned items combined. I'm still being creative and, to me, that's the most important part of being alive.

If you treat stock photography seriously, as you might any advertising or editorial assignment, you will net like results. If you treat it lightly, or as a secondary part of your business, the results will be the same: you will get out of it exactly what you put in. The equation goes: for every transparency you have in an agency, you will earn about a dollar per year after all is said and done. At least that's the equation the Image Bank follows and I've found it's a fairly accurate statement.

You don't have to be an Einstein to understand just what you have to put in to get something out: you have to take and make pictures. There is simply no other way. It's the same as with any other specialty of photography.

To me, to be able to bring all the elements of a good photograph—light, texture, graphics, and design—together and express them in many different ways is the most creative aspect of the art. And the possibility of using these images for stock photography affords me the opportunity to continue to expand my creativity.

Almost any picture you can take will find a market somewhere. If there is good quality in that transparency, it will sell, someplace. You will be astounded at what sells in this world market and wonder why you didn't start in the stock business long before now. The following are some examples of things that have sold over the years I've been involved with stock.

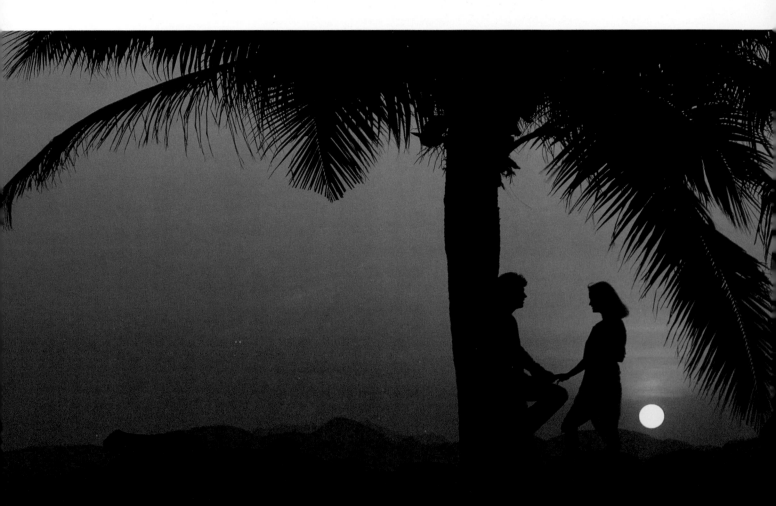

*S*uns and sunsets sell—always; big suns, sunsets over land, over water, with palms, and with pines. Don't however, put your sun in the middle of the frame. Leave room for titles, headlines, copy, products, and people. Give the art director some room to work; it will sell your picture again and again.

Suns with people, especially couples, have great potential. The silhouettes make them timeless and at the same time give the art director vast spaces for his copy and/or product. When you do silhouettes, make sure you are careful of the posing, the clothes your models wear, and the hairstyles. This type of picture can cover a multitude of sins, but it can also defeat you in many ways. A double chin, a big nose, "funny" hair, the wrong collar, the models standing too close, with no "air" between them, all make for an unsaleable picture. You are just wasting valuable time, both yours and the models', plus your own money, which can be very depressing. Hugging and kissing couples in the sunset are very tempting, but they will end up as a large black lump. This is not good. Lumps don't sell anything and don't sell period. Don't do lumps.

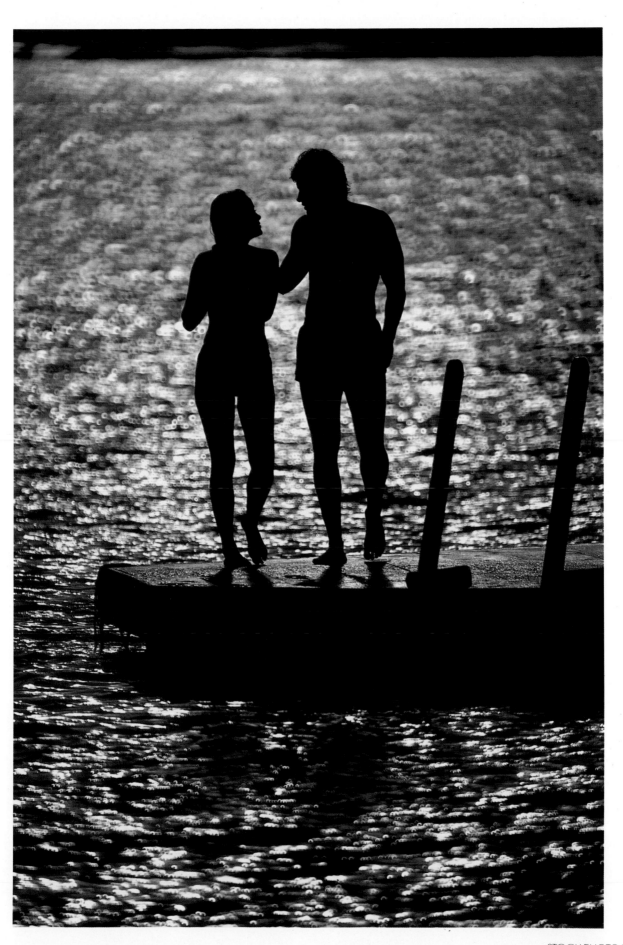

Couples without the sun also sell, including couples of all ages and all ethnic groups. Here you must be more careful in different ways. You can and, in most cases, should use models for their abilities to perform in front of the camera. They had better be very good and natural at their jobs or you will have a lot of unusable pictures. The pictures cannot look posed, except in rare cases. The look, the action, the hair, and the make-up should all be as natural as possible. The people should be involved in some activity that will bring all this about; it's best not to force a model into a situation he or she is not comfortable with, nor should you pair up two people who don't get along or work well together. If you are investing your own time and money, you certainly do not want to watch a war going on while the clock is running.

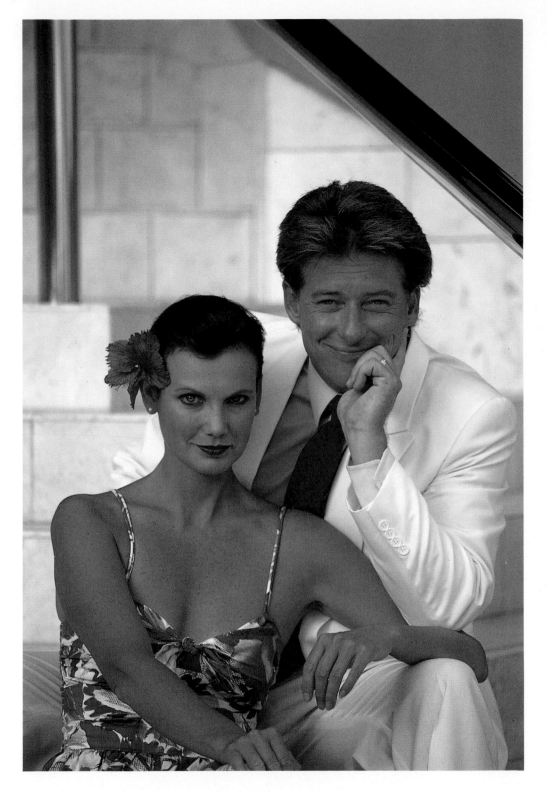

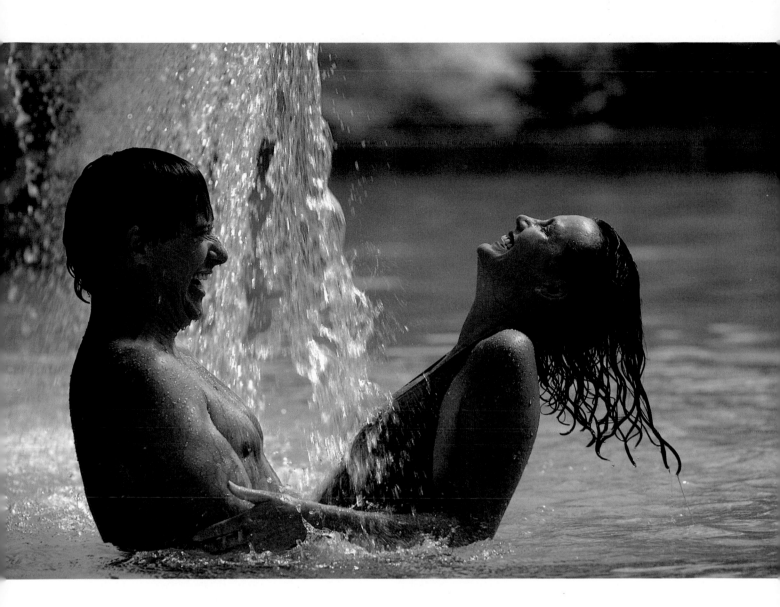

All of the situations shown here were planned and executed of my own volition, or time was tacked on to another assignment; deals were made with the models and the stock pictures were made after the assignment was completed. I always do the business negotiations up front; it does not work after the fact. The time and money are spent and if you cannot come to an agreement then, it can end up as time and money down the drain.

Stock can be a great investment of time if it's done properly and it can be great fun. You can take your assignment anywhere you like. There are also no art directors, not an account person or client in sight. It is also a great lesson in responsibility as it's your money, not some distant client's. This will give you the real understanding of having the shoe on the other foot and make you understand how all your clients feel during an advertising session. You'll now know why everyone gets so nervous when it doesn't seem to be going so well. It's a good lesson and a great way to experiment, to exorcise that everyday rut we all have a tendency to get caught in.

This picture was a "from the hip," taken enroute one day to a location scout for an assignment in the Colorado Rockies. I saw it developing from a moving car, the truck starting down this country road, the dust beginning to build up. We screeched to a stop and I had the shot in about two minutes. It has sold many times over and, more importantly, is a picture I've always liked personally. It really says "rural America," which is a very special place. I could have re-staged this picture, but it's difficult to do so on an advertising assignment. It's also absolutely taboo to use your time for stock when someone else is paying you. I felt a little sheepish about the two minutes, but fought it off with a lot of rationalization about fourteen-hour days, and working at dawn and dusk. After all, what does "day rate" mean, 24 hours a day? Sometimes, that's close to what's expected, as many photographers will attest.

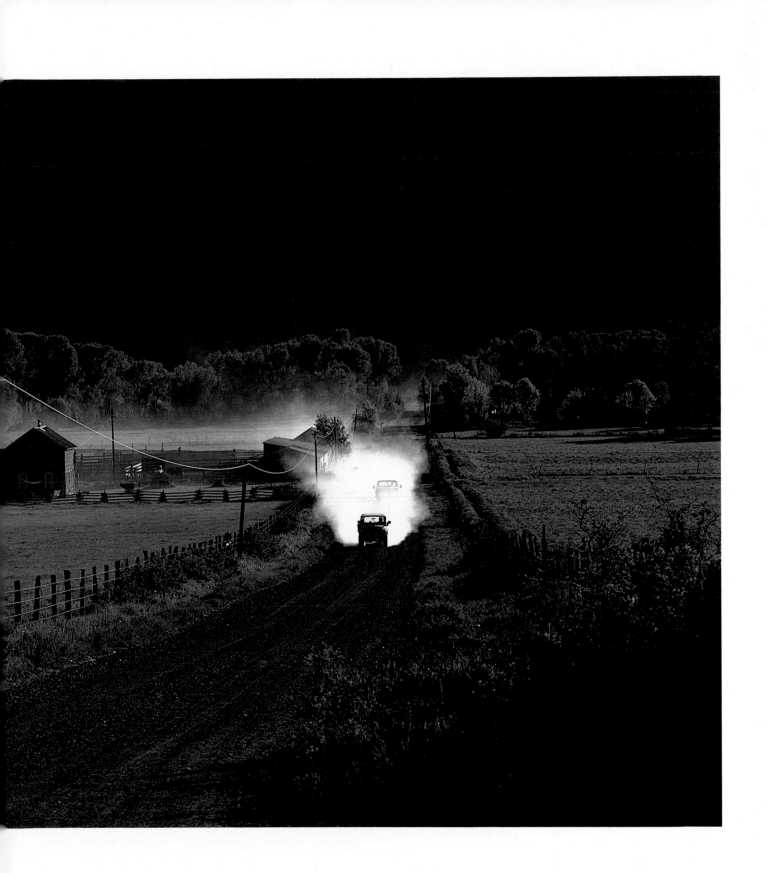

Stock is another great way to test your mettle, to stretch your imagination; it gives you license to experiment. No one is there to stop you or to influence you in any way. You are a free spirit except for the closed doors in your own mind. If you have the urge, you can throw open those barriers and do absolutely anything you desire. Here are a few pictures for which I have no idea of their use or potential saleability and, for the most part, I don't care. I loved doing them and they seemed like a good idea at the time. I have trays and trays of these "experiments," or what my assistant calls "lightbox wasteland" material—transparencies that end up in the area at the upper corner of your lightbox and collect dust for months, while you decide what to do with them. More often than not, of course, you don't do anything—but you never know.

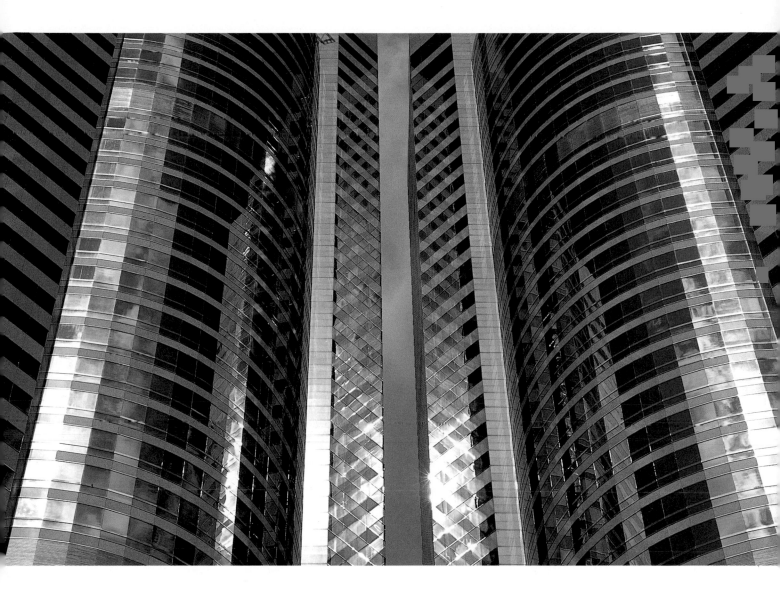

Experimentation can take many forms, it doesn't always have to be with film and processing; it can be in composition, use of color, different films, pushing yourself and your models, and finding new ways to use your talent and your equipment. It can manifest itself in many ways if you can just open those rusty doors. Hanging your cameras up between assignments is like hanging your life on a hook, while the world and your life slide by. There is nothing so terrible as wasted time, unless it be wasted talent and creativity.

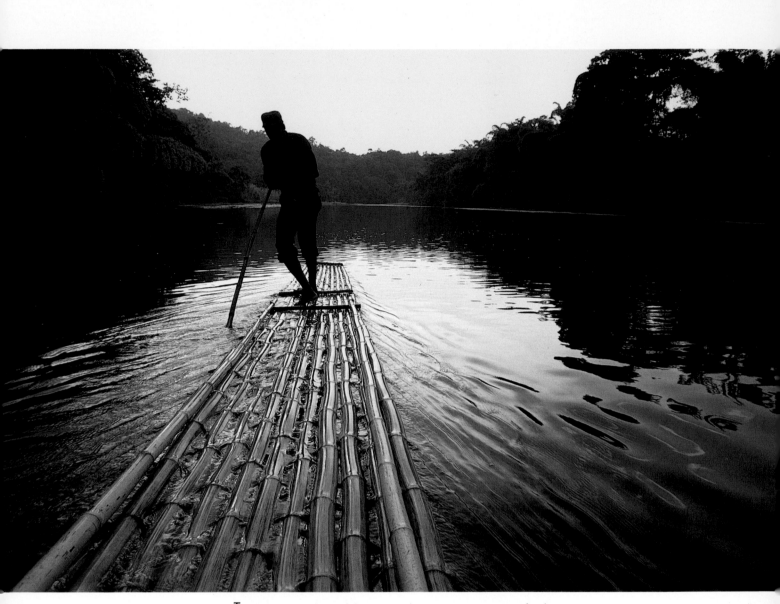

This picture was done while on assignment for Commodore Cruise Lines, while I was floating down a river in Jamaica. I took it after we had finished our situations with the models and I did send the picture to the art director, hoping he might find a way to use it. I knew in my heart it was too esoteric for the brochure, or even the ad, but I tried. So far I've only used the picture for promotional purposes and in this book. It was an effective spread in Select, a promotional vehicle published in Europe. The point is, the client saw it first.

My agency for existing photography is The Image Bank, based in New York. I probably have 80,000 images or more "in the Bank." The Image Bank is represented by almost forty office/libraries around the world, so it provides me with a perfect outlet, although it's not the agency for everyone. I travel that world and the Image Bank gives any picture the potential to sell forty times. I also want my pictures seen in countries just beginning to understand good photography. I often speak to groups of photographers in those areas, most recently in China. It's a rewarding experience, the sharing of things I've learned through the years. Best of all, I still learn from those I teach. Because of the travel to and within those countries, I've certainly gotten the best end of the deal.

Beyond the monetary gains you will receive from stock photography, there is creative satisfaction to be gained as well. Many of the photographs that I've sold through the Image Bank are those that I've taken for myself. To me, the most stimulating thing for a photographer, or any artist, is to experiment, take on new challenges, and do things you've never done before. And the reason why I've never chosen to become a specialist in any one thing is that it tends to keep you going in only one direction. I know a great many studio photographers, fashion photographers, food photographers, and "sheet metal" men who never shoot anything else—ever.

CONCLUSION

The future; it sits there waiting for us, a constant mystery ready to manifest itself in infinite ways. Can we influence what's coming? That's the ultimate unanswered question. If we've learned our lessons well through life, we realize how little we know. My lovely mother told me early on in my impatient life that the best half was the last half. I now realize just how right she was. I also realize just how little I know, not only about photography, but about life. But one thing is certain: I intend to keep learning about both and I will continue to travel about this world as a part of that process.

There is just too much to say about photography in this small volume. One may debate that it is too technical to be called "fine art," or merely a vehicle for illustrating history, or putting down the notion of the "decisive moment." Certainly these are all valid questions. Photographers are a strange lot, seeing things in very different ways. If we are lucky, they express what they see and we all benefit. As photographers, we are communicators and recorders of a part of history. That makes us a fortunate group, but if we don't take advantage of the opportunities we're offered, we've really missed the proverbial boat.

The tough test for photographers now is transition. Things are changing at a "future shock" pace and I doubt we realize it to any great degree. Photography as we know it today will probably not exist in as little as ten years. We have to adjust accordingly or be passed up in the rush. The next generation of photographers will indeed be marching to a different drummer.

Any negatives? I can think of only one, and it's questionable. I now see life through a small frame that is just 35mm wide. I find it difficult to just look and not photograph, especially with the continuing growth of my sales at The Image Bank. However, I still do believe, not only in daydreaming, but in recording images in your head and heart as well. It *is* elating just to watch the sunset sometimes, but after all, we do make money by selling pictures. And the only way to have pictures to sell is to make the photograph. You don't have to have an indiscriminate, machine-gun approach, but you *do* have to put film through the camera to make it work, not only for the financial rewards, but for the learning. It's not only the best way, it's the only way. Step outside yourself and your specialty, take on a challenge and experiment. Your rewards will be immeasurable.

ACKNOWLEDGMENTS

© Jeffery Chong

Since no one makes a success out of their life without some help, there are many people to mention and thank in too short a space.

If I could offer one lesson on achieving success in any business, it would be to take special care in choosing the people around you, the people that will make or break your professional life. I have been most fortunate in the past twelve years to have a very special woman running both my business and a good part of my personal life. Her name is Bunne Hartmann; she acts as "jack of all trades" in handling all phases of my business, managing the office and studio, the estimates, and overseeing the billing. She is the consummate producer, even finding the inevitable plumber when needed. You will not find anyone as special as this woman—she is with me and that makes me a very lucky photographer indeed.

Since I never really assisted during my climb up the photographic ladder, I probably don't have exactly the right perspective on assistants. I do know that assistants are critical, especially your first, or main assistant. In Paul Meyer, I have one of the best and he is on his way to becoming great. Paul is also doing more and more photography on his own. Your "First" is an extension of you and your thoughts, at camera and beyond, in areas you never dreamed. Pick a good one and treat him well and with respect—no yelling and screaming. It's just not necessary; remember where you came from. Thanks also to one of my former assistants and now successful photographer Brett Froomer. He made life on the job a joy. Go for the great picture, Brett!

For the past ten years, I've also been fortunate in being associated with Nob Hovde as my rep in New York. He is a legend in his own time on the streets and in the hallways of New York advertising. His association in recent years with ex-Ford model Pat Herron has only been a plus. She is a consumate professional and much nicer to look at over the lunch table than Nob, as charming and eloquent as he might be. On the West Coast, I've just signed with two slightly mad and wonderful women called Fox & Clark, so only time will tell. Derek Harmon and his lovely Sara Coates represent me in London, and although changes in worldwide advertising make it difficult to sell American photographers, I still have hopes for our European association.

Thanks also to my suppliers, mostly in Los Angeles, who have carried me in lean times: Pan Pacific, PRS, A&I, Sammy's, and of course, Eastman Kodak. Also to good friend Paul Schutt, owner of Helix in Chicago, who has also helped in many, many ways, in spite of his own troubled times. To my friend Jack Wiener, the London producer of *F/X*, whose advice has always been caring and from the bottom of a very big heart. Someday I'll beat him at tennis. To my fellow artist, director Stephen Verona for just being there (without his analyst) and being my friend. Paint, Stephen, and remember

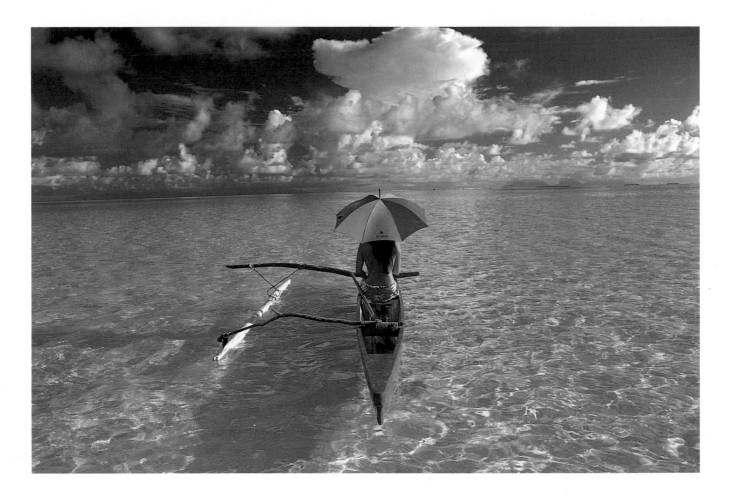

Big Sur. To Vince Tajiri, who dropped me in the middle of a rough sea and taught me how to swim in those early days. To Charlie Potts, whose "Law of Light" started it all. To Jim Woodman who taught me that life is always "fantastic." And to Ron Traeger, a beloved compatriot who was there in Madrid at my rebirth. I hope you can hear my thanks somewhere, Ron.

Thanks also, to my long time friend of over 25 years, photographer J. Barry O'Rourke, whose caring friendship has meant a great deal to me over the years. Thanks for all those long distance conversations filled with advice, freely given, unselfish introductions to clients and also for all the times spent over vodka martinis in the good old days. (You know what I mean, Barry?)

Deep thanks to my lovely mother, who put me here and raised me on her own. Good job, Mom! And to my wonderful and beautiful new wife, Corinna Liddell Gordon, whose support and love make any and all things possible and a joy as each day begins. Last and certainly not least, thanks to all the creative directors, art directors, art buyers, and editors who said, "Let's go with Larry Dale Gordon on this."

Photography, as all jobs, should be enjoyable and interesting. You should be thrilled to go to work each morning, and people like those I've praised above can make that a part of reality. If you don't reciprocate in kind to those around you you're in for a long, rough road, filled with unpleasant detours. Every time you change people or direction, it takes valuable time and drains your energy and emotions. This kind of lifestyle is the antithesis of what a creative artist needs to do his or her work. Plan carefully with regard to all things in your career, but most of all in terms of the people who will be a part of your professional and personal life. It will pay you enormous dividends—think of the friendships alone!

INDEX

Graphic production by Stanley Redfern